IMAGES
of America

WEBER COUNTY
IN WORLD WAR II

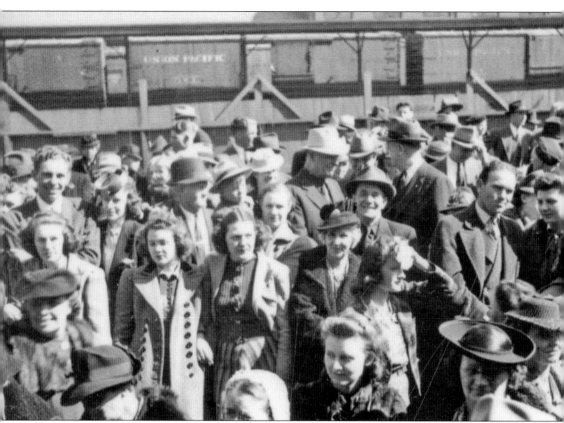

Early in March 1941, about 330 Utah National Guardsmen were sworn into the regular Army. Most were quartered at the converted Ogden livestock coliseum until they were shipped out to California for training. After spending one last day with their soldiers, family members gathered at Union Station on March 17 to wave farewell to the three trainloads of guardsmen. (Courtesy of Weber State University Special Collections.)

ON THE COVER: Entertainment for naval personnel at the Clearfield Naval Supply Depot was one of the many jobs taken care of by the welfare and recreation department. The US Navy built a new welfare building that provided a focal point for recreational activities, including a motion picture theater, pool halls, loungers, and a library. The department was also responsible for dances, such as the one pictured here. (Courtesy of Weber State University Special Collections.)

IMAGES
of America

WEBER COUNTY
IN WORLD WAR II

Sarah Langsdon Singh
and Melissa Johnson Francis

ARCADIA
PUBLISHING

Published by Arcadia Publishing
Charleston, South Carolina

Printed in the United States of America

Library of Congress Control Number: 2017945460

For all general information, please contact Arcadia Publishing:
Telephone 843-853-2070
Fax 843-853-0044
E-mail sales@arcadiapublishing.com
For customer service and orders:
Toll-Free 1-888-313-2665

Visit us on the Internet at www.arcadiapublishing.com

*To the men and women who served their country during World War II
and those who were willing to share their stories with us.*

CONTENTS

ACKNOWLEDGMENTS

This book documents some of the stories we have collected over the years at Weber State University Special Collections. Unless noted, all the images are from the collections at Weber State University. In particular, we were able to gain hundreds of photographs from members of the community who shared their stories about World War II with us.

We thank our editor at Arcadia Publishing, Liz Gurley, who guided and prodded us through the process. We would also like to thank the staff in the Stewart Library Special Collections who helped pick up the slack. We must also thank Weber County Recreation, Arts, Museums, and Parks; Lawrence T. and Janet T. Dee Foundation; Utah Humanities Council; and the Lindquist family for support in collecting these histories.

Several people have paved the way for this book through their research, writing, and enthusiasm for Ogden's history. This includes the tireless historians at Hill Field Air Base and Defense Depot Ogden who took care of the records and passed them to us. We express our gratitude to the *Standard-Examiner* and its growing digital archives. Without that resource, no chronicler—past or present—can tell Ogden's story.

INTRODUCTION

At the Weber State University Stewart Library Special Collections, we seek to document the history of Weber and Davis Counties here in northern Utah. We do this in a variety of ways. First, we collect primary sources, records of families, individuals, businesses, clubs, and other organizations. We collect photographs as well and now have almost 300 collections containing tens of thousands of images. Most of the photographs in this book come from these collections. But for us, the most interesting way of documenting the history of our community has to be through oral histories.

Working with our oral historian, Lorrie Rands, we have completed several oral history projects over the years, with each one adding depth and richness to our collections. Our decision to start an oral history project on World War II in northern Utah began with a simple question. While working with a family donating their father's papers to us, we were asked, "What are you going to do with all of this?" It is a question that we often hear, and we assure our donors that apart from preserving collections, we also try to share them. But this time, the question really got us thinking. Their father had served in the Army during World War II, and his collection included hundreds of amazing photographs. We started to think about other collections and materials we had related to the war: uniforms, scrapbooks, and memorabilia. The more we looked, the more we found, and we knew that this was the right project for us to start next.

Our primary goal when beginning this project was to speak to veterans and those who served on the home front. We wanted to recognize those who had sacrificed while serving in the military, and share their experiences. We also knew that many changes occurred in this community during the war, and we wanted to capture that experience as well.

Prior to World War II, northern Utah was primarily an agricultural community. The valley was dotted with large farms and orchards, and almost every town had at least a small canning company. Quick access to the railroad made it easy to ship both fresh and canned produce all over the western United States. Ogden's stockyard was also one of the largest in the West, with millions of head of livestock coming through each year.

Before the bombing of Pearl Harbor and an official declaration of war, the US government had been quietly gearing up for a fight. President Roosevelt and other leaders knew the United States could not stay out of the conflict for much longer, so efforts were made to increase supplies, machinery, and the number of military installations across the country. Local leaders recognized an opportunity, and began working to draw the federal government's attention toward Utah.

The Ogden Chamber of Commerce worked particularly hard to bring military installations to the region. They quickly formed a committee dedicated to that purpose and worked with state and national leaders to gain the necessary approvals. Eventually, through their efforts three new installations were built: Hill Field (later Hill Air Force Base), Defense Depot Ogden, and the Clearfield Naval Supply Depot. The Ogden Arsenal, built after World War I, was significantly expanded during World War II, and Bushnell, a military hospital, was opened in Brigham City, Utah.

The impact of these depots and installations on northern Utah was immense and is still felt today. Victory workers, as depot employees became known, were recruited not just in Utah, but throughout the intermountain region and nationally. Well-paying jobs were welcome so soon after the Great Depression, and the population of northern Utah boomed. Housing developments, built to accommodate these employees, expanded towns all along the Wasatch Front, and public transportation routes were adjusted so workers could travel from Salt Lake City, Logan, and even Idaho.

As large numbers of men around the country enlisted or were drafted into the military, women took their places in the workforce. Elderly men and women, as well as high school students, also helped pick up the slack. Although agriculture remained an important part of the war effort—US troops needed to be fed and allied countries were facing food shortages—the military installations offered better pay. Women in particular were afforded more opportunities than were previously available, and earned more money than ever before.

But beyond all of this, northern Utahans, and all Americans, were caught up in a shared purpose. Soldiers overseas felt they were fighting for a noble cause, but were comforted knowing that their families at home were safe and doing their part as well—and they did indeed do their part. Victory was the goal of every man, woman, and child. They volunteered with the Red Cross, became cadet nurses or air raid wardens, gathered scrap materials, and bought war bonds. They planted victory gardens, rented rooms to victory workers, and even bought victory garbage cans—made with less aluminum so as not to deplete needed materials for the war. Their sacrifices were made more bearable because they were done for the war effort.

These things became such a part of daily life, it has been difficult for us to gather these home-front experiences. The biggest hurdle in this project has been the fact that most people undervalue their own stories, but this was truly everyone's war. Communities responded in ways never seen before and probably never to be seen again. These stories are such an important part of our history, and it has been our pleasure to work with our interviewees. Few things bring as much satisfaction as witnessing the moment an individual realizes their story is important, and that someone is excited to listen.

This book is the culmination of almost two years of work. We have learned so much from our interviewees about this important time in our community's history. We are excited to finally share their stories. We hope you enjoy them and treasure them as much as we do.

One

THE FIGHT HAS JUST BEGUN

THE EUROPEAN FRONT

With the bombing of Pearl Harbor on December 7, 1941, the United States quickly declared war against Japan, Germany, and Italy. Troops from across the country joined others from Canada, Britain, and Australia to fight the Axis powers and restore peace to the world. Operation Torch began in the fall of 1942 to take North Africa in order to gain control over the Mediterranean for the invasions of Italy and the rest of Europe. After initial fighting with the French troops, the soldiers made way to Tunisia to engage the Germans and Italians in battle. On May 12, 1943, about 275,000 German and Italians surrendered. In July and August 1943, the Sicilian campaign started, and 160,000 troops invaded Sicily, driving the Germans up the Italian peninsula. Italy declared armistice on September 8, 1943, as the American troops continued to chase the Germans out of Italy.

On June 6, 1944, air and naval bombardments of Normandy began with Americans gaining a firm foothold on Europe at the end of the first day. By July 1, there were over one million men fighting on the beaches of Normandy. The fighting continued throughout France and into Germany. In December 1944, the Germans surprised the American troops at the Battle of the Bulge. The Americans were able to fight back and regain the ground they had lost at the start of the battle. In April 1945, Russian and American troops met in Berlin and took control of the city. The last battles effectively ended the war with Germany and allowed the United States to turn all its attention to the Pacific front.

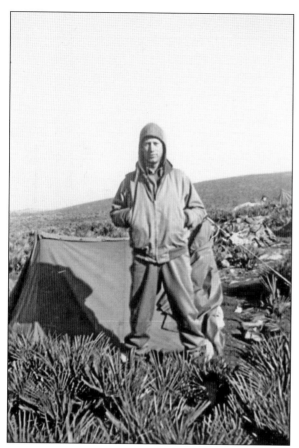

Don Emerson was one of the many men who answered the call to join the service after Pearl Harbor. He was in the Army and was sent to North Africa. Emerson said, "The British, who were already fighting the Germans in Tripoli and over in that part of North Africa, we're supposed to go to the front lines to help the British. We spent all spring and summer fighting the Germans. Our first big encounter was on a hill called 609. The Germans had it pretty well under their control and I'll never forget, I went up there after a big battle. Some of our trucks, big six-by trucks were up there and there was a crew up there picking up the dead. They were throwing them into a truck like cordwood, piling them in there. We lost all kinds of people . . . lost 1800 people."

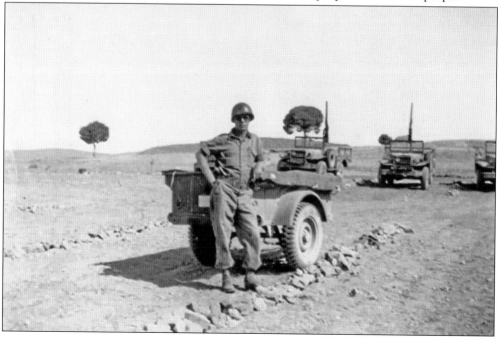

During his time in Italy, Don Emerson was able to take leave for a few days in Rome and met a young Italian girl: "I met her and she was quite an educated little girl. She'd been to seven different colleges in Europe. She took me to operas and I lived for five days with her and her mother in an apartment. It was just like I was home."

Lt. Col. Barney White (left) and Lt. Col. Jack Norris each served in the military during the war. White was part of the 9th Field Artillery of the 3rd Infantry. He was part of the invasion troops in North Africa. In 1942, he was awarded battle stars for his action in combat. Norris was a West Point graduate and was with the 2nd Battalion, 38th Infantry. He served in the European Theater. Both men became ROTC instructors at Ogden High School after the war.

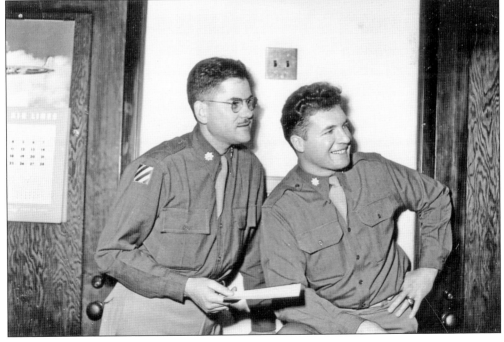

Eugene "Pete" Miller was originally from Tennessee and graduated from Virginia Polytechnic Institute. In 1939, he joined the Army and served overseas. During his time in the military, he rose to the rank of major. Following the end of World War II, he became an instructor of military tactics at Ogden High, where he taught for two years. He helped teach map reading, marksmanship, scouting, rifle range procedure, military history, and the manual of arms, drill, and command. Miller was called back into active duty during the Korean War, where he was killed in action. He was posthumously awarded the Legion of Merit medal. Seen to the left is Pete Miller when he entered the Army in 1939, and below are ROTC classes at Ogden High during 1946–1948.

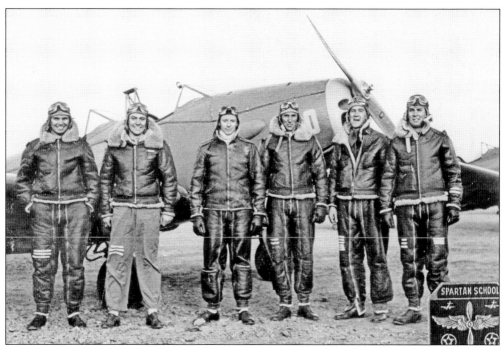

John A. Lindquist entered the service in April 1942. By October 1943, he had graduated from the West Texas Bombardier Quadrangle, Midland Army Airfield, in Midland Texas. Above, Lindquist is at far right along with his fellow trainees (from left to right) E.W. Smith, R.W Myer, L.L. Miner, H.B. Williams, and J.M. Lockhart. Lindquist was decorated six times for courage and skill in aerial combat while serving as a bombardier on an 8th Air Force B-17 Flying Fortress based in England. Lindquist completed more than 30 flights in his plane *Our Achin' Lass*. He is seen at right ready to leave on one of his many flights. In 1945, he was sent home on leave to Utah after he served his allotted missions for the US Army Air Corps in the European Theater.

During the war, John Lindquist was stationed in England. His squadron was responsible for bombing attacks against airfields, bridges, supply dumps, and gun emplacements to support the Allied drive into France. He also flew many long-range missions to bomb war industries in Germany. Above is a photograph of the barracks where Lindquist was stationed. He is surrounded by his fellow Army pilots from across the United States. Lindquist served three and a half years with the Army Air Forces. He flew over targets in Germany, France, and Czechoslovakia, including U-boat pens and oil industries. He was awarded the Air Medal with five oak leaf clusters, the European–African–Middle Eastern Campaign Medal, and five Bronze Stars as part of the group that flew support missions during the Normandy invasion in June 1944. Below are pilots returning to base after a successful mission.

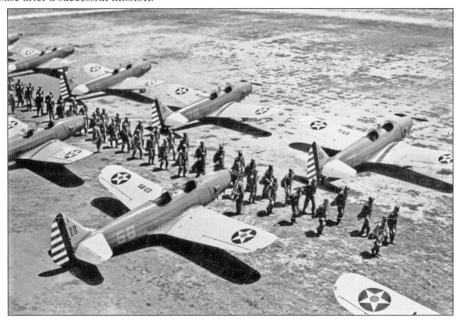

DeLoss Eggleston was a member of the military police stationed in Europe. After the signing of the armistice, he was sent to Berlin to help patrol the American section of the city, which was mainly residential. Eggleston said, "I was with the military police and our company was just all by itself. There was a battalion of military police, but we were just a company sent to guard the military headquarters. We didn't have radios in ours so we could go anyplace we wanted. I volunteered to go on patrol, and I would go out and take pictures and come back. I went to the American sector, then the French, the British and even also got stuck in the Russian zone." Eggleston can be seen in his MP uniform at right; below is part of the American zone of Berlin that he patrolled daily.

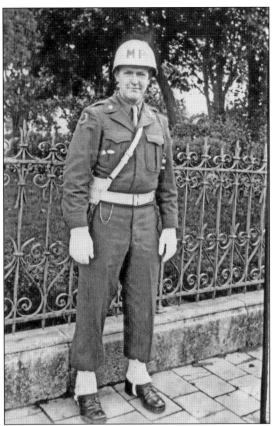

Jim Favero joined the Army in December 1942. He said, "I was a mess cook, and it was my job to feed them." He remembers being around Naples in 1944, as the Germans kept bombing the bridge the Americans were in control of. His company would have to go out and try to repair it: "We had to take chow to them, so we took it out in five of these hotpots and had it all laid out for the men to come in off the river and eat."

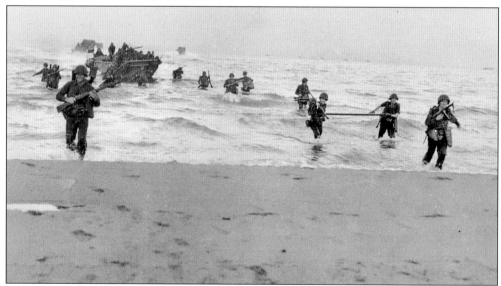

On September 5, 1943, Jim Favero was part of the Salerno landing. He recalled being on a British troop ship and then transferred to a DUKW ("Duck") to get to the beach. Favero said, "They needed the ducks because the big ships could only go in so far. When the ducks hit the dirt, the ramps go down and you run out." He remembered there were more men lost on Salerno than Normandy because at the time the Germans controlled the air and the surrounding area.

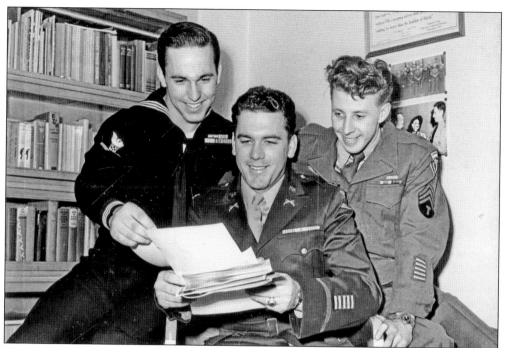

The Roberts family of Ogden symbolized the typical wartime family as they sent their young sons off to war. Kenneth Roberts (left) served in the Navy on the USS *Guadalcanal*. His ship captured German subs. David Roberts (center) entered the Army in June 1942 and served on the Pacific front in Okinawa. Jayson Holladay (right) entered the service in November 1942 with an assignment to the American embassy in Paris to naturalize soldiers. He was married to a sister of the Roberts brothers.

Maj. Mickey Dominique was an officer assigned to Hill Field during 1942–1943. During his time at Hill Field, he coached football, boxing, and basketball. He went on to serve in England, France, Austria, and Germany. He met and married an Ogdenite, Joan Korb, during his time at Hill. After his discharge from the military, he settled in Louisiana.

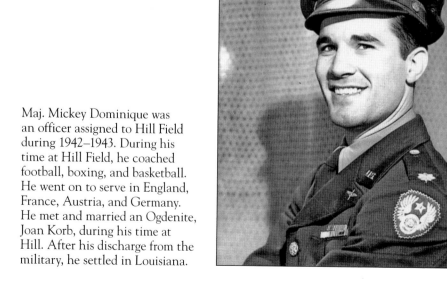

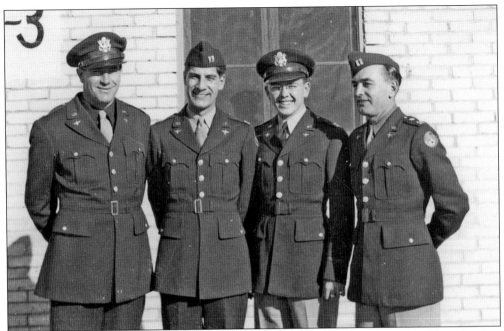

Thomas D. Dee II joined the Army in April 1942. After completing cryptography school in Florida, he was assigned to the 19th Army Airways Communication Squadron (AACS). He was first stationed in the Belgian Congo but traveled throughout North Africa. The AACS was responsible for providing communication access to the troops fighting in the area, and Dee was eventually promoted to commanding officer of the squadron. He is pictured above with other members of his squadron. From left to right are Capt. Charles LaTourette, Capt. Garth Harding, Dee, and Capt. Max Beck. Pictured below is the 19th Squadron in their temporary headquarters in Heliopolis, Egypt, in 1943.

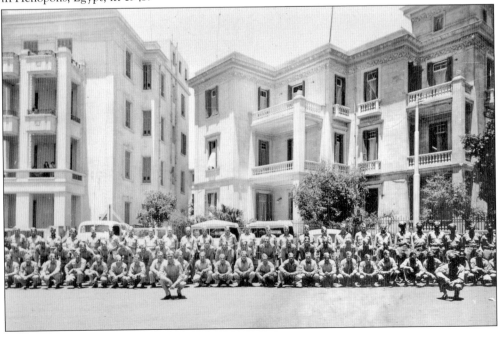

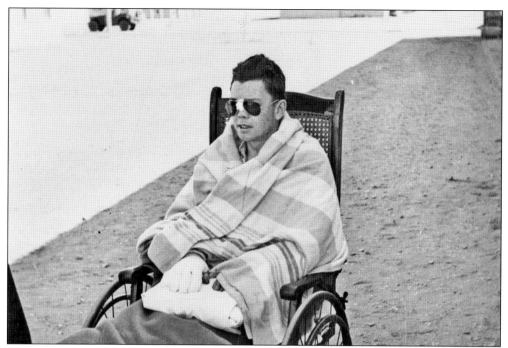

Thomas Dee loved flying and his many travels in Africa. In March 1944, he and several other squadron members traveled to Iraq. He wrote home to his parents telling them how much he enjoyed the trip. A few days later, while traveling home, a sandstorm hit his plane, and they crashed about 20 miles from their airfield in Cairo. Four crew members were killed, and Dee was severely injured. His nose was broken, he had second degree burns on both hands, and his legs, also severely burned, required skin grafts to heal. He spent three months in the hospital before he was well enough to travel and his doctors sent him home to Bushnell Hospital for further surgeries. After a long recovery, Dee was finally able to return to duty in 1945, serving stateside until the war ended.

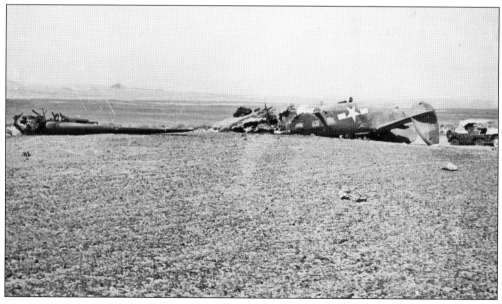

Efforts were made to keep morale up for the troops in North Africa. In addition to visits to the private beach pictured here, Thomas Dee remembered attending movies and dances and even coaching his squadron's baseball team. It was not all fun for him though; his time in Africa also included yellow fever, dysentery, and a bout of malaria.

The Women's Army Auxiliary Corps (later Women's Army Corps, or WAC) was established in 1942. Apart from Army and Navy nurses, WACs were the only military women to serve overseas. Shortly after the Allies regained control of North Africa, Gen. Dwight Eisenhower requested WAC stenographers and switchboard operators for his office. These WACs serving in Africa were the first sent overseas. The group of WACs pictured here served with Tom Dee in Egypt.

Cyril Kay Stowell was a member of the Army Air Corps, joining just after he graduated from high school. He served as a C-47 Skytrain pilot in the European Theater. The plane was used for aerial transportation by the American and British militaries. Stowell supported aerial drops of paratroopers and cargo, evacuated wounded service members, and flew VIPs throughout the war. He stated, "What touched me the most happened after Germany surrendered. We had the honor of flying our US infantry troops in an aerial tour over the Italian battlefronts that they had courageously fought through." His portrait is at the Pentagon as a member of the US Air Force "Pioneers in Blue." To the right is Stowell's portrait, and below is one of the captured Nazi planes at the Italian air base where Stowell was stationed.

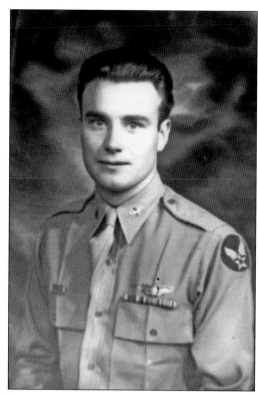

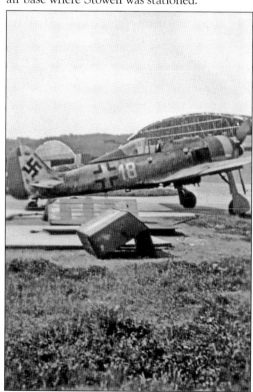

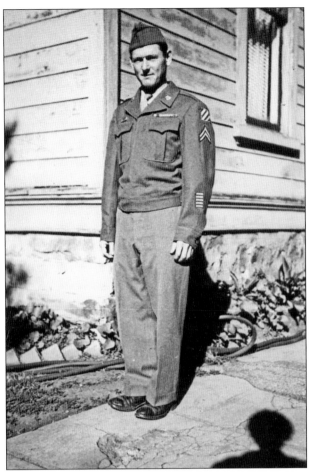

Theodore Raty joined the Army in October 1940 and served until July 1945. He was stationed with the 41st Field Artillery and saw action in Algeria, Italy, France, and Germany as the military chased the Germans back to their homes. In a letter he wrote home to his sister, he stated, "Everywhere the Americans go, the people of liberated villages turn out en masse to greet the boys and, if there is anything left, to wine and dine them." He was awarded the American Defense Service Medal and French Croix de Guerre for his actions during the war. Raty is seen at left in his military gear shortly after he returned home in 1945. The image below shows Raty with an artillery piece in Italy in 1944.

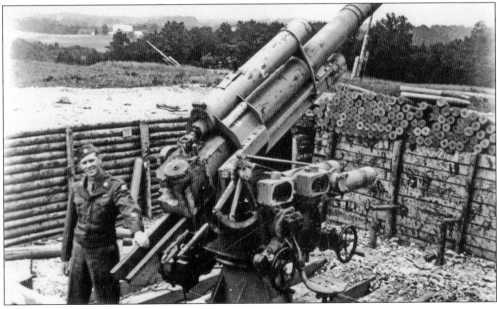

Two

FINISH THE JOB
THE PACIFIC FRONT

With war raging on the European front, the United States faced heavy resistance from the Japanese in the Pacific. In 1942, the United States lost the Philippines after the supply routes were cut off by the Japanese. This led to the campaign of Guadalcanal, where US Marines took the island and the Russell Islands to establish a presence in the Solomon Islands. During the same time, the Army took New Guinea. In 1943, the China-Burma-India campaign attempted to establish a supply route through Burma into China. The summer of 1944 saw the Allies clearing Burma and the construction of the Ledo Road and a fuel oil pipeline from India and China. At the same time, other military troops drove into the Philippines to keep the Japanese forces divided in the Pacific. In February 1945, the Marines invaded Iwo Jima. After a month of severe fighting that resulted in the loss of 20,000 Americans, the island was finally taken on March 16, 1945. From there, the military launched an amphibious assault on Okinawa in April. The United States again faced heavy losses due to the Japanese kamikaze pilots who purposely crashed their planes into the ships. Over 35,000 Americans lost their lives taking Okinawa. After such horrific fighting and loss of life in the Pacific, the US government decided to drop atomic bombs over Hiroshima and Nagasaki on August 6 and 9, 1945. The pilot and crew of the *Enola Gay*, which dropped the bomb on Hiroshima, had trained at Wendover Air Field on the border of Utah and Nevada, which was under the jurisdiction of Hill Air Force Base. The bombing of the two Japanese cities effectively ended the war.

Donnell Stewart spent World War II stationed in Tezgaon, India. The military planned to set up a route across South China to Japan to establish air bases. Stewart worked in the assistant aircraft maintenance office. He often wrote home about dealing with high temperatures, rainfall, and the presence of tigers, snakes, and monkeys. The air base became part of the air route to fly VIPs, medical personnel, and released POWs back to the United States. Stewart was often sent out into Burma and western China to help locate and repair downed aircraft. Donnell is seen at left outside his housing in India, and the image below image shows the Liberty ship that brought him home from Calcutta.

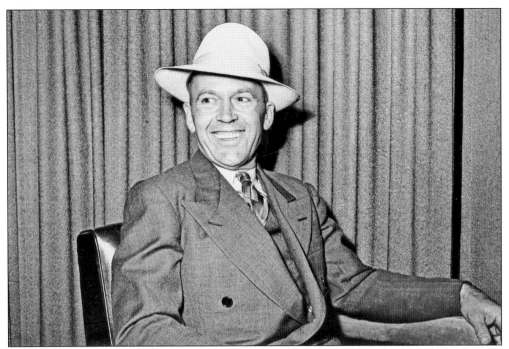

Mark Lewis Streeter was a civilian construction worker employed by Morrison-Knudsen on Wake Island in 1941. On December 23, 1941, the Japanese attacked the island and took 1,200 Americans as prisoners of war. Streeter was held captive for 54 months and was treated the same as military POWs, including beatings, starvation, and torture. He was rescued by American occupation forces in 1945.

Soldiers took every opportunity to return home during leave or furloughs. Here, Helen and Henry Eldredge Jr. enjoy his nine days of leave from San Diego, where he had been training for the Navy. He joined the Navy on March 12, 1945. Eldredge had previously been employed at the *Ogden Standard Examiner*. The couple were married on December 11, 1944, and enjoyed a few months together before he was shipped off to Tokyo.

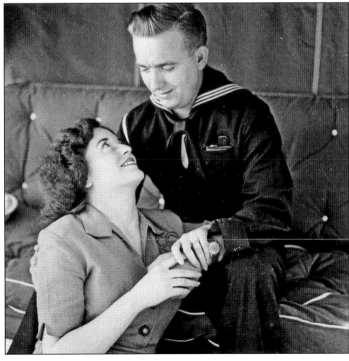

Carl DeYoung joined the Navy and was promoted to ensign after his graduation from the Naval Reserve Midshipman School. He was stationed on Landing Craft, Tank 1243 in the Pacific Theater outside Okinawa. In 1945, he received the following citation for action during the typhoon that struck Okinawa: "While serving on board LCT 1243 during the typhoon that swept Okinawa October 9, 1945, by your actions and tireless work, you saved said craft from destruction on the reefs during the ISO-knot wind when engine trouble prevented said craft from getting underway. For your service and actions you are hereby commended." DeYoung is seen at left just after his graduation and below in a picture of his craft, LCT 1243.

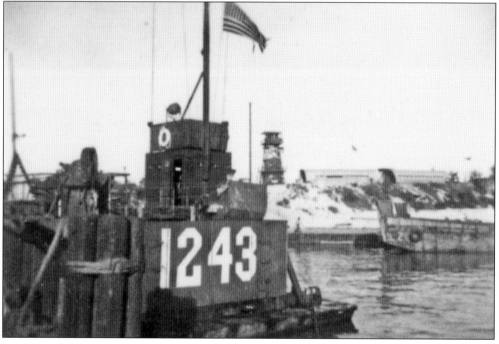

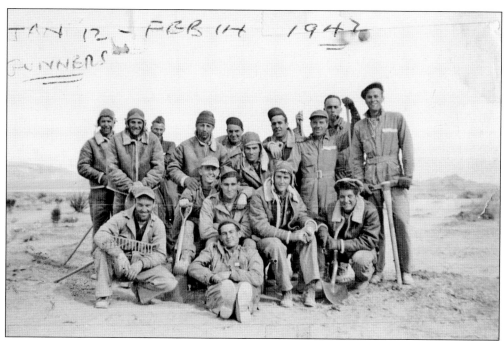

JAN 12 - FEB 14 1942
GUNNERS

Nathan Mazer joined the Army Air Corps and was a student at the Las Vegas Army Air Field, AAC Gunnery School beginning in January 1942. The school trained 600 fighter pilots and bomber crewmen every five weeks from the Las Vegas school. They received training using shotguns mounted on the back of trucks, and then in bombers in flight. Mazer is seen here in the back row, fourth from the left, with the rest of his training crew.

Capt. Jack Ogden Lynch entered the Army on February 17, 1941. He was stationed in the Pacific. In 1945, he was in Okinawa and then transferred to Kobe, Japan. During his time in Japan, he visited Yokohama and Hiroshima to see what was left after the atomic bombs had hit the cities. During his time in Japan, he celebrated Utah's Pioneer Day on July 24 by watching "the fireworks" of artillery shells overhead on the beach.

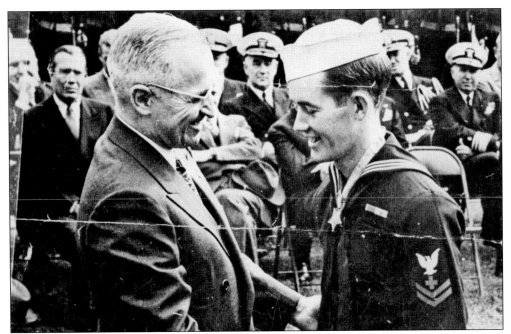

George Wahlen received the Congressional Medal of Honor from President Truman. He also received the Navy Cross and the Gold Star, the Purple Heart with two clusters, a presidential citation, and the Asiatic-Pacific Campaign Medal with two battle stars. Wahlen received the Medal of Honor for heroism on Iwo Jima while attached to a Marine Corps unit. Although painfully wounded, he refused to leave the field and treated other wounded men.

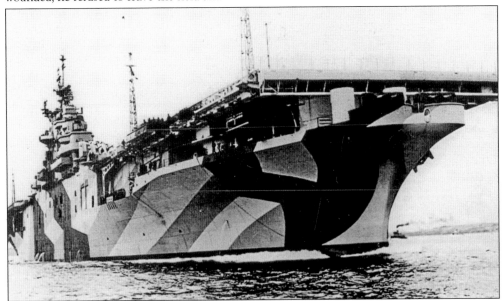

Jim Coyner joined the Navy right out of high school. After boot camp, he was sent to carpenter school to be a carpenter's mate. He has assigned to the USS *Hancock* and served in five major battles in the Pacific, including Iwo Jima, Okinawa, two Philippines battles, and Japan. The *Hancock* fought bravely against kamikazes as well as a raging typhoon. Coyner was discharged in March 1946.

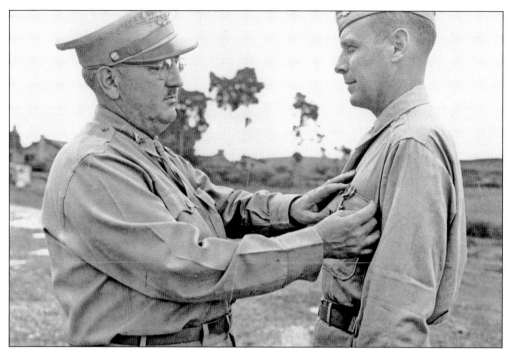

Junior Rich served with Chinese combat units during the central Burma campaign. He served as a consultant surgeon for the front-line units at Lashio, Hsipaw, and Kutkai. Often, his medical supplies were dropped from planes. Colonel Rich supervised the activation of a hospital in Kweiyang, China, where he was chief of surgery during the war. He received a citation from the Chinese army for instructing Army doctors in surgery. He also was awarded the Asiatic-Pacific Campaign Medal with battle stars and a Bronze Star, as seen above. He returned to the United States as a medical attendant to Lt. George Barr, one of the original Doolittle Fliers, who had been in prison in Nanking, China, since the famous raid there. The image below shows Rich standing next to the directional sign on the Lashio Road.

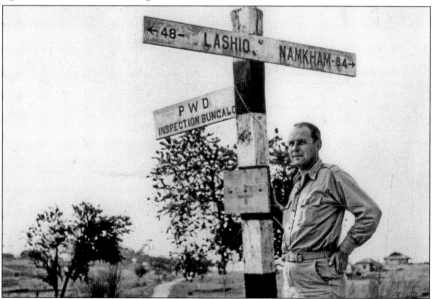

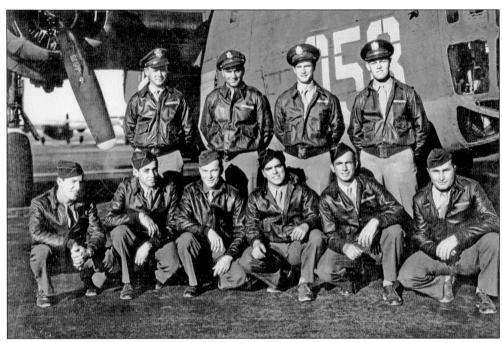

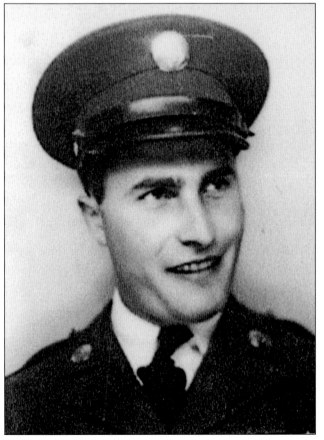

Chris Markos joined the Army Air Corps in June 1942. After training, his squadron was sent to Kansas to pick up a brand-new B-24 and receive their orders for overseas combat duty. There were 10 men on the crew, and they remained together the entire time they were deployed in the South Pacific, with the exception of the pilot. The crew is seen above next to their bomber. On March 19, 1944, their mission was to attack a Japanese supply convoy in the Bismarck Sea. They engaged Japanese fighters, and heavy fire was exchanged. This was Markos's first time in live combat, and he engaged the enemy with his 50-caliber machine gun. The Japanese ships were annihilated in a total of five hours and thirty minutes.

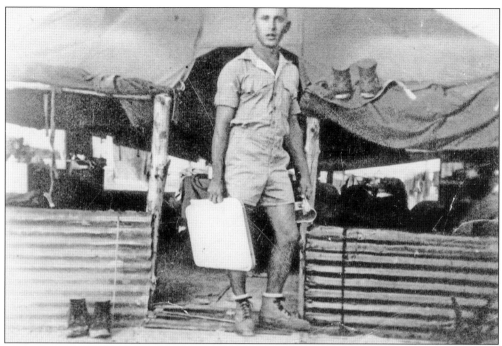

Victor Steinfeld joined the Marines and was on active duty beginning in October 1943. He was a heavy gun crewman and was sent to the Pacific. There, he fought in the Mariana and Palau Island campaign. The Marines captured Palau to cut off the Japanese forces in the East Indies. The Battle of Peleliu ranked with Iwo Jima as one of the bloodiest in the Pacific, with the highest casualties by any Marine unit. A total of 1,121 Marines were killed in action, 73 went missing, and 5,142 were wounded in action. The Japanese suffered losses over 13,000. The number of prisoners taken by the US forces was less than 300. In the photograph above, Steinfeld is seen on Peleliu Island outside the tents. The image below shows American GIs holding some of the captured Japanese POWs.

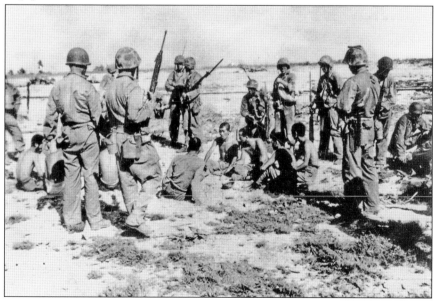

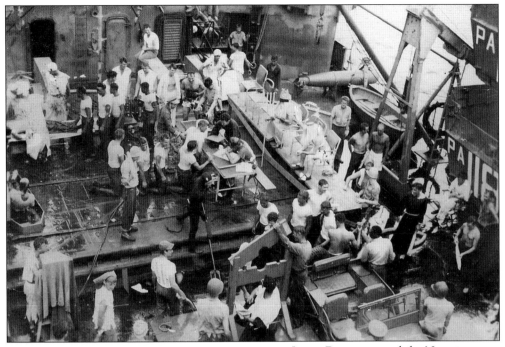

James Deamer joined the Navy in February 1944 and was assigned to the USS *Hendry*. The troops were among the initial invasion forces on Iwo Jima. For six days in February 1945, the *Hendry* unloaded troops and supplies onto the beaches of the island. The ship survived fierce kamikaze attacks, and thanks to the gunners on board and those of the supporting ships, the *Hendry* remained free from damage. Here, some of the ship's crew are participating in a line-crossing ceremony at the equator.

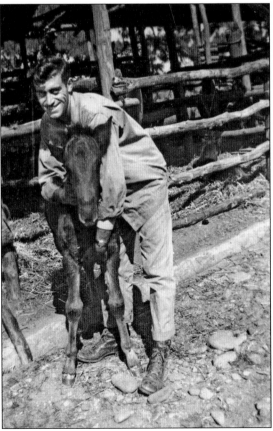

Glen Stewart was part of the 39th Veterinary Division, stationed in Shillong, India. The 39th was charged with the inspection of food and ensuring proper handling of all meat products. Part of Stewart's duties was to provide support and instruction in veterinary animal services to the Chinese in both India and China. He is seen here with a horse at the hospital in Shillong.

Three

Uncle Sam Wants You
Stateside Service

After war was declared in 1941, Weber and Davis County citizens entered all the services of the military and served in all the major areas of combat. A total of 7,723 Weber County residents were in uniform, and Davis County saw 2,293 young men join the ranks. By the end of the war, Weber County counted 161 among the dead or missing, and 40 for Davis County. The men served on all fronts in different capacities. Some were medical doctors stationed in military hospitals around the world. Some received flight training and became transportation pilots responsible for getting the men and equipment to various bases. There were bomber pilots who flew missions into Germany, attacking from the air. There were train operators who were responsible for the transportation of equipment from storage to the front.

The young men often returned home to northern Utah on furlough after their training before they were sent overseas. This gave them a chance to tell their families about their training and even marry their sweethearts before they were shipped off to war. The military training for many started early when they joined the ROTC at Ogden High School. During the war years, every young man joined and received basic training before joining the military after graduation.

Bushnell Hospital operated in Brigham City from August 1942 to June 1946. The hospital specialized in treating amputations and was one of the first to administer penicillin to patients. The buildings included 17 wards, 6 operating rooms, 12 dental areas, and isolation rooms, along with patient barracks and housing for nurses and doctors. Part of the patients' days included recreational rehab including skiing, fishing, swimming, miniature golf, and dancing. Volunteers provided supplies and aid to the hospital. Men and women from the local area visited to boost morale, assist in rehab, and teach the injured GIs new skills. The hospital was frequently visited by celebrities such as Tommy Dorsey, Nat King Cole, Gary Cooper, Bob Hope, and Bing Crosby.

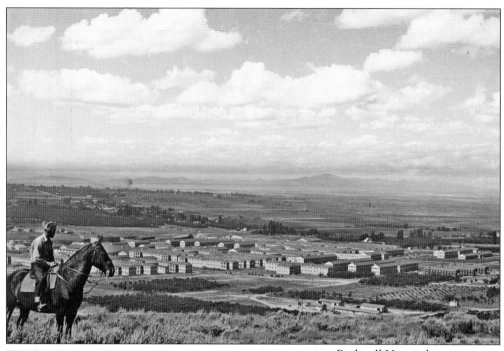

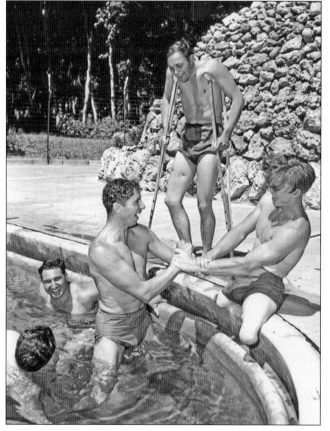

Bushnell Hospital was built in Brigham City in 1942–1943. The 1,500-bed hospital was for wounded soldiers and amputees in the Intermountain West. It was one of the first to administer penicillin to patients. The complex was completed with 60 buildings, including spaces for entertainment and housing. Shown in this photograph is a patient on horseback looking down at the hospital among the fruit orchards.

Bushnell Hospital had a year-round swimming pool built for the patients. Instruction was under the direction of Don Powers, who taught swimming strokes that helped the patients by strengthening muscles and increasing the range of motion of injured limbs. Even those with psychiatric problems improved when they used the pool. (Courtesy of Utah State History.)

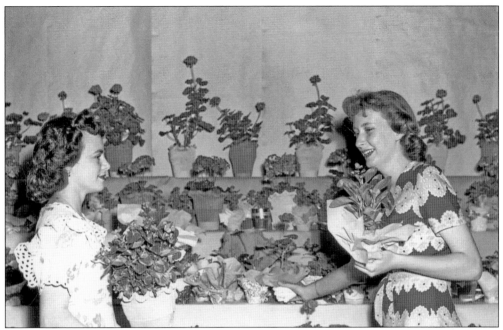

The Junior Red Cross at Ogden High School donated 650 potted plants to Bushnell as Easter gifts for the patients. Each plant was hand decorated with paper and a ribbon. Seen here are Mary Lenske (left) and Lesley Hill. They, along with 70 other girls, made the presentation under the direction of Edna Benning and Mary Johnson.

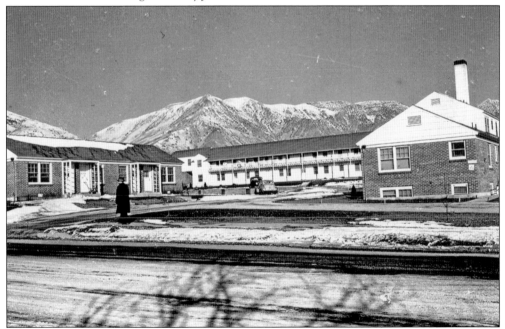

The government built 64 homes to house people coming to Brigham City to see relatives in the hospital. The Federal Housing Administration project cost over $280,000 and it was always full when Bushnell was in operation. Brigham City spent over $3 million on military housing for the hospital as well. Following the closing of Bushnell, the homes were converted into Bushnell Lodge.

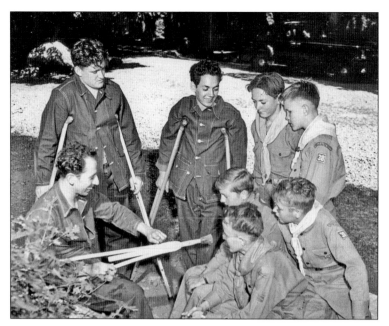

Boy Scout Troop 38 from Hooper, Utah, spent some time visiting patients at Bushnell Hospital. In 1945, the Boy Scouts along with the Weber Wildlife Federation had a drive for equipment to be loaned to servicemen and patients of Bushnell. The boys visited to help boost morale, play games, and assist the men with small chores. (Courtesy of Utah State History.)

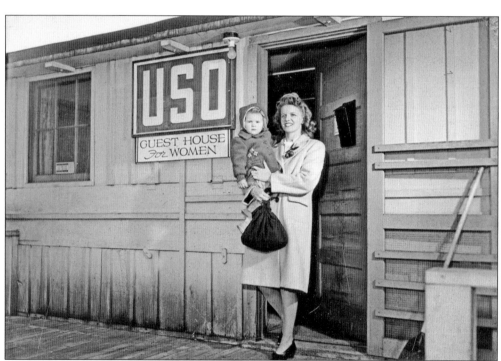

In March 1945, a USO dormitory for mothers, sweethearts, and wives of patients was opened. There were nine sleeping rooms each with bunk beds to help with the increase of guests. A total of 20 guests per day were registered at the guesthouse. A large lounge provided a place for relaxing, writing letters, or reading. The USO also included laundry facilities and a place to prepare a quick meal. (Courtesy of Utah State History.)

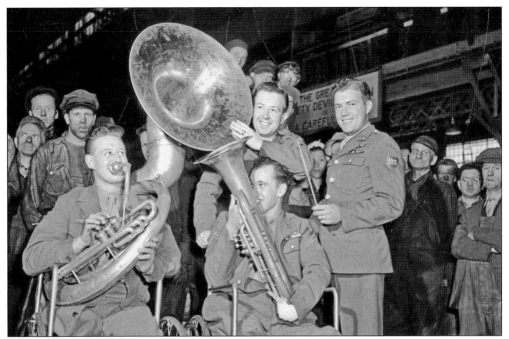

Brigham City citizens contributed records, musical instruments, portable phonographs, songbooks, sheet music, and recording equipment to furnish a music library at Bushnell. The Red Cross chapter donated a piano to the hospital. This led to a military band being organized that offered concerts around northern Utah. In 1943, they played at the Hooper Fair and Rodeo during lunch. All patients from Bushnell were invited to attend for free. (Courtesy of Utah State History.)

Pictured here are just four of the thousands of Ogdenites who joined the military during the war. These men were on 10-day leave. From left to right are Earl Stuart, Jack Wahlen, Gene Wahlen, and Jay Horspool. They all enlisted through the Ogden recruiting station at the post office, and were seeking reassignment in the aviation corps.

Veterans Dorothy Van Dam (ex-WAC) and Harry Herscovitz organized a World War II "Welcome Home" dance on October 4, 1946, to be held at White City Ballroom. The dance was sponsored by the Democratic Veterans' Committee of Weber County. The veterans needed a discharge emblem or a copy of their service discharge to attend. Women without male escorts were admitted free of charge to ensure plenty of dancing partners.

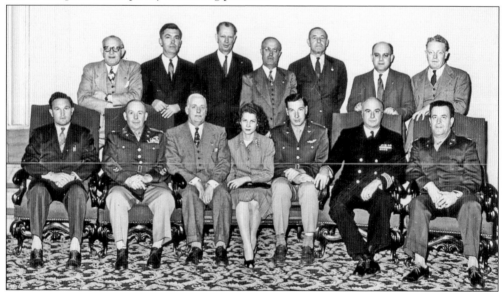

Shown here are members of the military committee and officials who took part in Ogden's Community Chest drive. The members were representatives from Utah General Depot, Hill Field, Clearfield Naval Supply, and Ogden Arsenal. The drive held several special events aimed at obtaining funds for charity purposes. It was an all-out effort to have Ogden be the first to "go over the top."

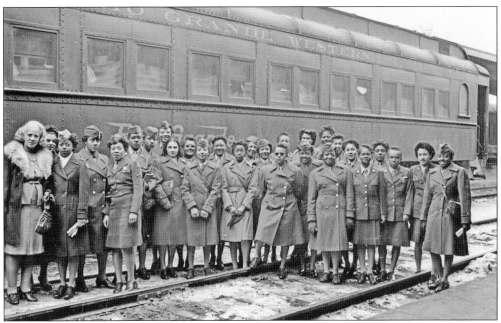

A group of African American WACs are waiting outside a Denver & Rio Grande train to head out to the front. The women were part of the 9th Command that drew from the western states. The recruiters used the film *To the Ladies*, which portrayed women as responsible, mature adults worthy of respect. They hosted luncheons and teas to get women to join the WACs. (Courtesy of Utah State History.)

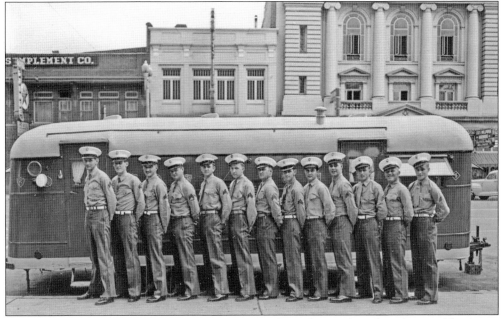

John Surrage, local recruiter for the Marine Corps, is shown here at far right. The portable Marine Corps recruiting station stopped for a week in Ogden in front of the City-County building. The sergeants were touring the Pacific area to recruit men 17 to 26 years of age to join the Marines. The bus was set up to answer questions and process applications as rapidly as possible.

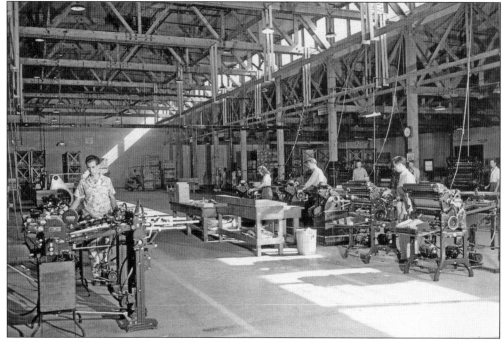

The Army field printing plant at the Utah General Depot had 13 offset presses with skilled operators. The plant printed 750,000 units a day. It was one of three plants that the Army designated for printing all Army leaflets and forms for all of the Pacific area and Alaska. Its 35 employees operated under the direction of Cecil Jorgensen.

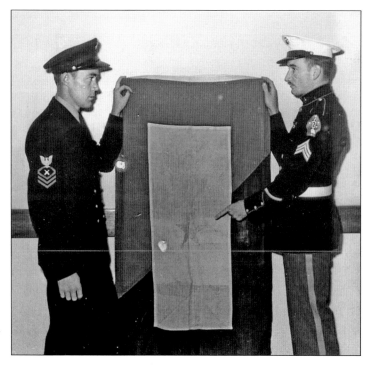

Navy chief Richard Buehler and Sgt. Alfred Turner of the US Marine Corp examine a Gold Star banner. The banner symbolized both the living and dead of the four branches of the military. Red was army; white, air services; and blue, navy/marines. A gold star was centered on one side representing those who died, and a blue star on the other was for those still in service.

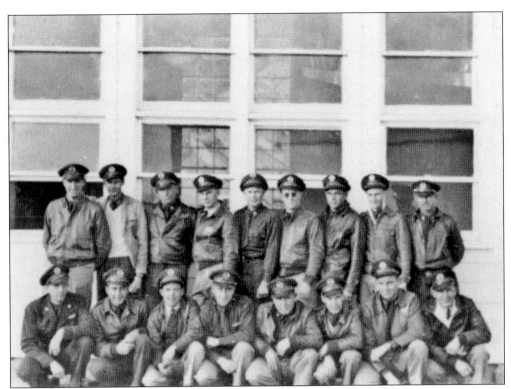

A total of 110 naval aviation cadets were assigned to Weber College in May 1943. Lt. Comdr. Channing Manning was responsible for the ground training, and Art Mortenson, manager of Utah Pacific Airways, directed the flight training. The Navy supplied 20 to 30 planes for the training school at the Hinckley airport. The flight instructors are shown here outside one of the hangars. (Courtesy of Ogden Union Station.)

Reminders of the war were everywhere throughout Ogden. Shown here is a display for the Ogden High School Military Ball that was held at White City Ballroom. The display was front and center in the women's lingerie department at J.C. Penney. The military uniform is juxtaposed against women's stockings and undergarments.

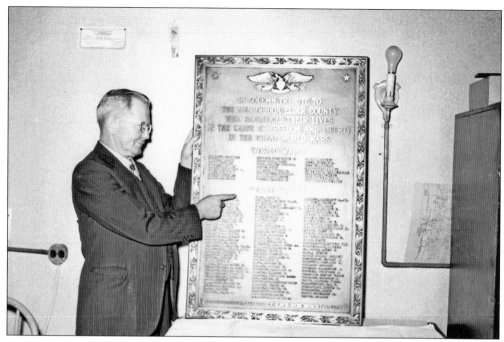

Brigham City wanted to create a monument to the brave men and women who lost their lives during World Wars I and II. Here, Milton Thorne views the bronze plaque that carried the names of the men killed during the wars. The citizens of Brigham City raised funds to place the war memorial on the courthouse grounds.

On May 2, 1944, the Women's Services caravan arrived early in the morning in Ogden and parked vehicles around City Hall Park and conducted two free street shows for the citizens. There was a parade in downtown Ogden that included 150 Marines, bands, and the parade marshal Gus Becker. He is shown here with his aides, SPAR (US Coast Guard women's reserve) Mary Elizabeth Clapper (left) and WAVE (US Navy women's reserve) Sylvia Kiosterud (right). (Courtesy of Ogden Union Station.)

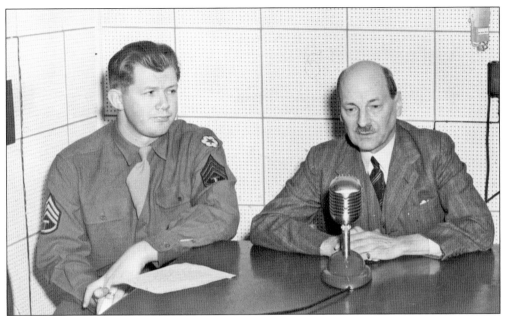

Mark Evans Austad was in the Army during World War II when he was sent to Walter Reed Hospital for surgery on his shoulder and knee. During his time at the hospital, he served as an announcer and program director for the hospital radio station. WRGH was a station run by soldiers for the 3,000 patients. Listeners were able to request the music they wanted, as well as listen to the AP wires and baseball games. Austad started roundtable discussions that included guests such as First Lady Eleanor Roosevelt and Prime Minister Clement Atley, seen above at right. Austad advocated for bond sales back home in Ogden. He wrote the paper telling the stories of soldiers in Ward 31 who were among the worst injured. Pictured below is Austad (second from right) with some of the staff at Walter Reed.

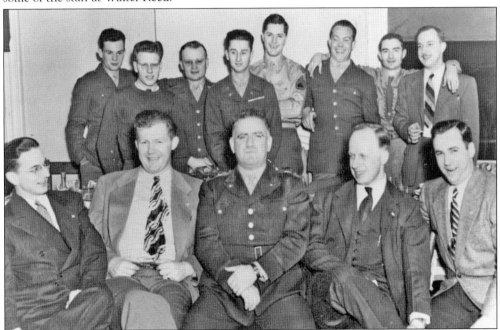

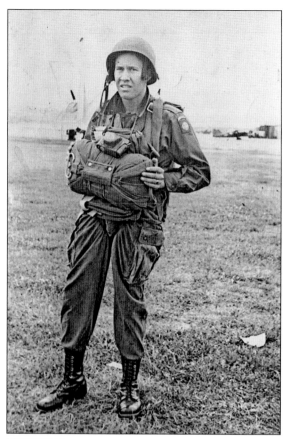

Dean Hurst joined the Army during the war and decided to volunteer for the paratroopers: "My going to paratroops when I did, it altered the whole course of my life to a degree. I was put in the 517th as soon as I graduated because the plans for the invasion of Japan had already been set in stone. I was put into one of the airborne units that would have been jumping in Japan, which frankly would have been disastrous. As the war was ending I was assigned to the 13th Airborne Division, which they closed as soon as the war was over so I was reassigned to the one remaining airborne unit, the 82nd airborne division." At left is Hurst preparing to jump with the 82nd. Below, paratroopers jump out of a plane.

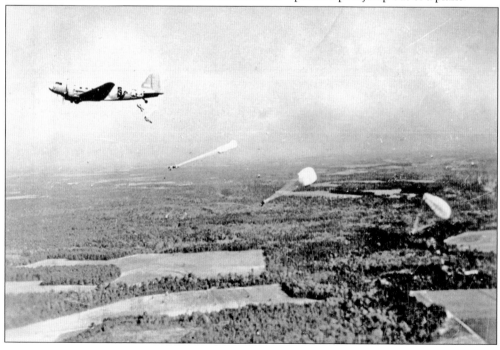

Following the war, Dean Hurst became part of Gen. James Gavin's 82nd Airborne Honor Guard. Hurst recalled, "We had special uniforms, we did special drills, it was a company of the 505th regiment. We had white ladder lace boots, and we had a white ascot. Most of us had enough ribbons on by the time, and you wore the divisional stuff. You had the American theater, good conduct and victory medals. I had that plus my expert infantryman and my parachute wings."

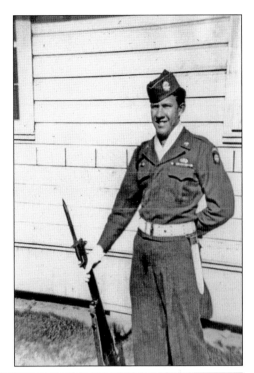

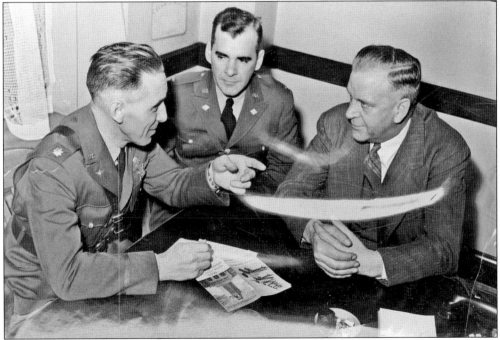

Early in 1941, Maj. Malcolm Buchanan (left) and Lt. Thomas Lee (center) met with Ezra Fjeldsted of the Ogden Chamber of Commerce to discuss the Army's flying cadets program. Unmarried men from ages 20 to 26 were encouraged to apply for the program. Those who were accepted received $75 a month to complete extensive training, after which they received a second lieutenant's commission in the Army Air Corps Reserve.

Members of Ogden High School's ROTC were trained in map reading, drill tactics and maneuvers, and marksmanship. Each year the cadets with the best marksmanship skills were invited to join the rifle team. The team was led by Sgt. Douglas "Texas" Parker, and they competed in several national competitions.

Farrell R. Collett (fourth from left) was head of Weber State's art department for many years. He joined the Navy in 1942, commissioned as a lieutenant. By the time the war ended he had been promoted to lieutenant commander. Collett spent his military career stateside as a mine sweeping instructor and producing training aids for the Navy. When he returned to Weber, he taught classes especially adapted for veterans.

Four

WORK TO KEEP 'EM FIRING
HILL FIELD AND OGDEN ARSENAL

In 1919, the Army Ordnance Department proposed that storage facilities be built to contain the war surplus left over from World War I. The Army chose a site in Sunset, Utah, just south of Ogden. The railroad connections and transportation routes were the most important factors in the decision. The dry, sandy land was perfect to absorb a great portion of a shock should there be any accidental explosions. By 1923, there were 35 storage facilities for ammunition as well as an administration building and other service buildings. Following a rehabilitation of the depot in 1935, the arsenal was expanded to include facilities for loading and storing small caliber artillery shells. At the height of the war, the arsenal served to store and ship vehicles, ammunition, small arms, and artillery pieces. The arsenal employed over 6,000 people during the war. In 1954, the arsenal became part of Hill Air Force Base.

Hill Air Force Base was established in north Davis County after the city received an $8 million congressional appropriation in 1939. Initial construction started in 1938 with the official groundbreaking in 1940. Hill Field served as a major supply and maintenance depot until 1943, when it was upgraded as a separate command unit. The mission shifted to the repair of aircraft engines, parachutes, radios, bombsights, and the winterization of aircraft. By 1943, there were 15,780 civilian employees at Hill Field. From 1940 to 1950, the population of Layton increased from 646 to 3,456 due to the establishment of the military bases. Hundreds of housing units were built on or near the base to provide the workers with a place to live. Many local residents took in military personnel who were transferred to the base until the housing was completed. The end of the war placed Hill Field in the role of storage depot for aircraft. The base repaired and kept the machines in perfect condition for the conflicts to come, including Korea and Vietnam.

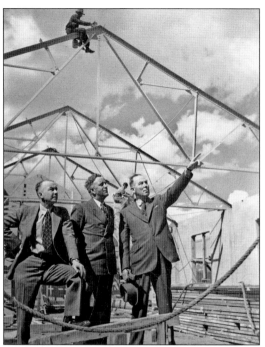

Following World War I, the Army was faced with the problem of enormous surplus of munitions and where to store them. The Ogden Arsenal became one of the storage facilities for the surplus. During the 1930s, the Works Progress Administration sent 1,150 workers to build the structures at the arsenal. Pictured are, from left to right, LeRoy Young, Ogden Chamber of Commerce president; Lon Romney, commerce secretary; and Frank M. Browning, chairman of the Military Affairs Committee.

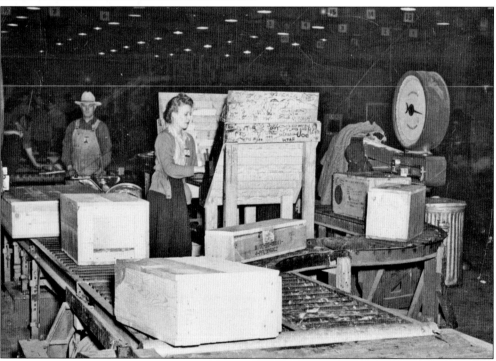

The Ogden Arsenal shipping department was run mostly by women during the war. Two women would keep links and shells pouring through a machine that linked the ammunition into a belt. A third woman then packed the belt into a metal container that was watertight and moisture-proof for shipment overseas. Shown here is an unidentified woman performing the task as expertly and quickly as a man.

Barbara Gardner was one of the many women who answered the call to work at military installations. She got a job at the Ogden Arsenal as a shell loader packing ammunition. Over her years working, she advanced numerous times because of her hard work and dedication. Seen below is just one of her many advancement forms. Gardner is seen at right posing for her arsenal identification. During her employment, she was also required to get a special arsenal driver's license that allowed her to drive government vehicles and on base. She was actively involved in the women's sports teams, playing both basketball and softball over the years. Gardner worked through the end of the war until her soon-to-be husband returned home from service.

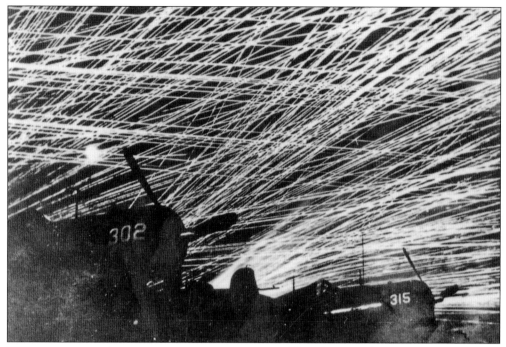

Phosphorus and strontium were combined and pressed into tracer and igniter pellets in plants at the Ogden Arsenal. These pellets were then transferred to the loading building, where completed rounds were assembled before being shipped to combat areas in the Pacific. In this photograph, Carl DeYoung captured the light of tracer rounds from his Navy ship.

The East Shell Loading softball team won the 1942 championship of the female league at the Ogden Arsenal. They won 5-3 over the East Fuze Plant in the final game of the season. Seen here are, from left to right, (first row) Barbara Gardner, Grace Anderson, and Mary Bishop; (second row) Mary Wheatley, Viola Lee, Lois Howard, Elma Avondet, and Stella Sims; (third row) Velda Stagge, Rulon Cannon (manager), Helen King, and Gwendolyn Wheatley.

To help build the massive military installation of Hill Field, WPA workers were sent from around the West to complete construction. Pictured here are Charles Jensen (left) and Edwin Cox. Both had decades of experience in carpentry. They were part of the skilled workforce that completed the two buildings of the quartermaster warehouse/commissary and garage/shop in just under nine months in 1940. (Courtesy of Utah State History.)

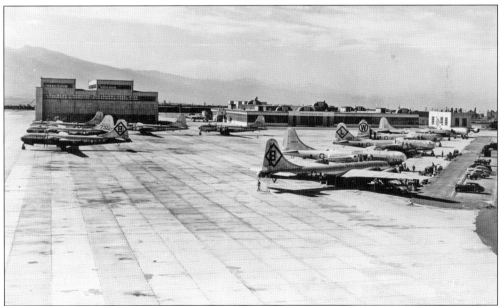

The Boeing B-29 made its first flight in September 1942. By 1945, there were nearly 4,000 in the skies between the Mariana Islands and Japan. The Air Force chose Hill Field for storage of the Superfortresses. The process would protect the $90 million investment by the taxpayers of America. The aircraft were phased out in 1960 when the last four were retired from active duty.

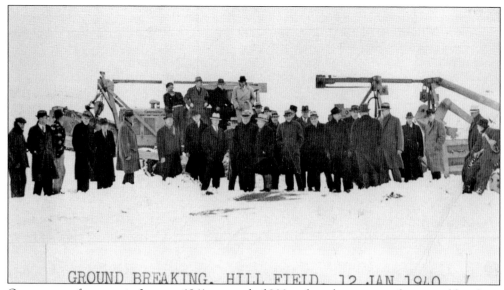

GROUND BREAKING, HILL FIELD, 12 JAN 1941

On a snowy afternoon in January 1941, a crowd of 200 gathered to witness the ground-breaking ceremony for the first building of the new Army air depot. Frank M. Browning, chairman of the Ogden Chamber of Commerce military affairs committee, turned the first shovelful of dirt. Captain Kester L. Hastings, constructing quartermaster, noted that the honor was given to Browning because he had been instrumental in "getting the site and keeping the ball rolling."

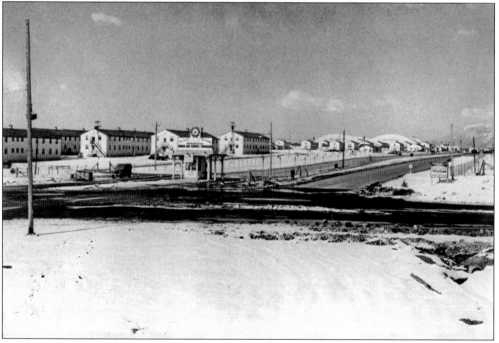

Headquartered at Hill Field, the Ogden Air Technical Service Command performed maintenance on aircraft during the war. One of its most important tasks was working on B-24 bombers sent from the European Theater for reconditioning and storage before being sent to the Pacific. Engines were "pickled," or lubricated with preservation oil, and carefully wrapped in waterproof cloth to prevent rusting. (Courtesy of Hill Air Force Base.)

Construction bids for buildings at Hill Air Depot were received a month after the ground-breaking ceremony. Initial plans estimated costs at $3.5 million for 20 buildings, including warehouses, hangars, and barracks. Shown here are the enlisted men's barracks, which contained a snack bar, soda fountain, and a post exchange.

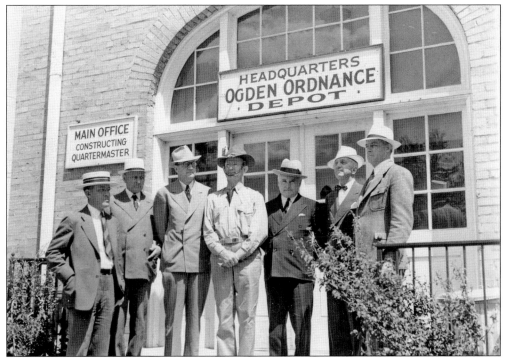

Built in the 1920s to store excess and obsolete munitions after World War I, the Ogden Ordnance Depot was later named the Ogden Arsenal. In 1935, WPA assistance allowed for major renovations of the depot. After World War II broke out, the government spent $6.1 million on further expansions and renovations. Construction at the depot in the 1940s was overseen by Lt. Col. Elmer G. Thomas, constructing quartermaster.

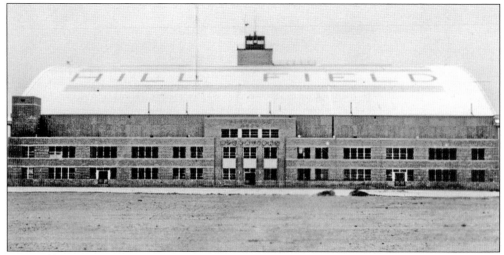

Pictured here is the Aircraft Operations Hangar shortly before construction was completed in October 1941. The hangar was just one of several building projects still incomplete when Col. Morris Berman arrived in November 1940 as the depot's first commanding officer. The total cost for the hangar's construction was over $500,000, but that cost paled next to the nearly $1.4 million spent on Hill Field's four runways, also completed that fall. (Courtesy of Hill Air Force Base.)

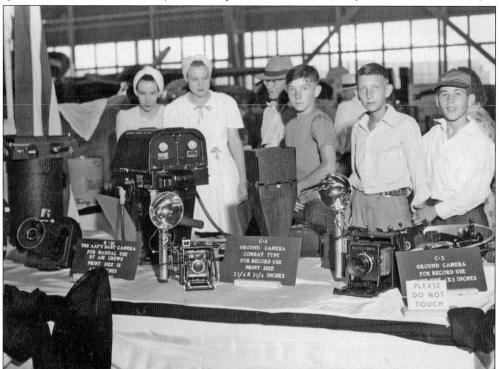

In 1945, the Air Corps opened Hill Field to a series of open houses for the general public. The military had aircraft and weapons on display to show the citizens how their hard work was helping the war effort. The latest types of aircraft supplies and the B-29 Superfortress bomber were shown. Over 1,000 people from the community toured during each open house. In this image, a group of schoolchildren take the tour.

During World War II, older and married women joined the labor force in large numbers. Female typists, stenographers, and card-punch operators were paid between $1,260 and $1,440 per year at the military installations. The wages were a great increase over the other jobs usually available to women. After the war, many remained and changed the female labor force from young and unmarried to an older and married composition.

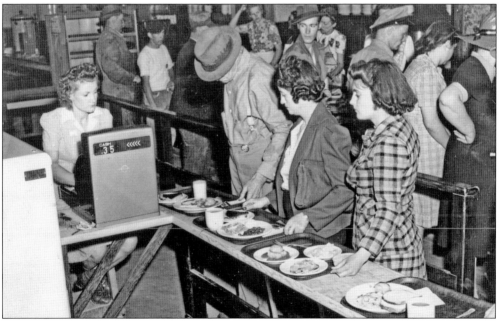

In August 1942, a new cafeteria was built to solve the problem of feeding several thousand war workers. The room was designed along the line of Army mess halls, with two wings each seating 900. The cafeteria included a fountain to serve light snacks and soft drinks. The revenue from the cafeteria was given to the welfare association to sponsor social functions and sports programs. (Courtesy of Ogden Union Station.)

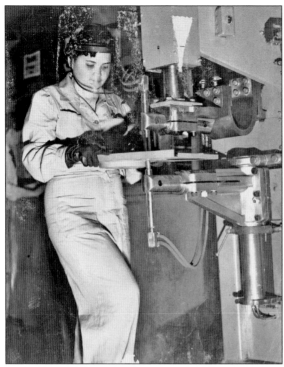

In 1942, Weber College enrolled 500 male and female students into the mechanic learners training program. This three-month course gave them instruction in engine mechanics, sheet metal, machine shop, aircraft welding, painting, and leather and canvas. The graduates were then placed in air depots to help meet the shortage of mechanics during the war. Shown here is one of the young women mechanics who worked at Hill Field.

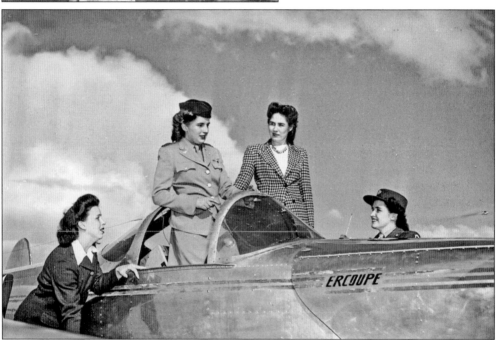

In 1944, the Civil Air Patrol promised to help recruit women to join the ranks of the WACs. Part of the incentive was a ride in the Ercoupe airplane. Shown here are new recruits, from left to right, Faye Strawn, 2nd Lt. Melba Sutherland, Kathrine Smith, and Technician Fourth Grade Helen Fowell. Women from ages 20 to 40 with no children under 14 were eligible for enlistment. (Courtesy of Utah State History.)

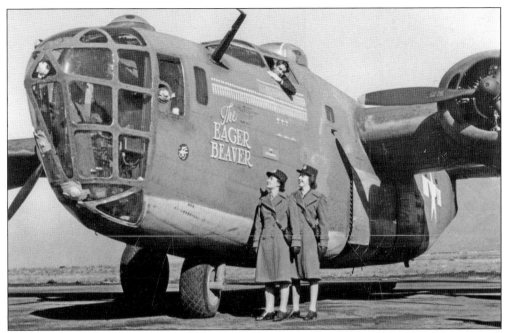

The Eager Beaver, one of the B-24 Liberator bombers, arrived at Hill Field in December 1943 for repairs. Flown by 1st Lt. Charles Whittlock on 77 bombing missions, the plane and crew sunk one destroyer and two supply ships, and downed three Japanese Zeros. Pictured by the plane are WAC second lieutenants Betty A. Richardson (left) and Ione C. Conaway. (Courtesy of Hill Air Force Base.)

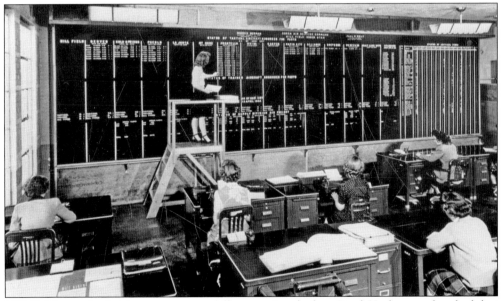

Hill Field's supply division was not yet fully operational when Pearl Harbor was bombed, but personnel had to work quickly to receive tons of supplies intended for the Philippines. Warehouses were double-stacked, but supplies still overflowed into parking lots until more warehouses were completed. Shown here is the Supply Division in 1944, using their large "menu board" to keep track of grounded aircraft and parts. (Courtesy of Hill Air Force Base.)

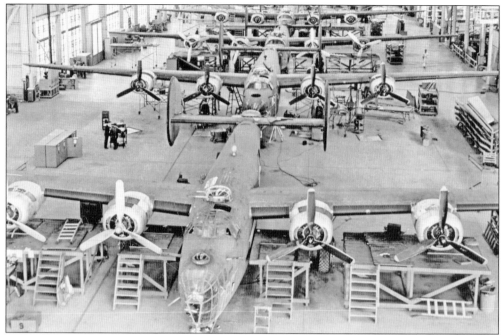

In February 1943, Hill Field maintenance crews set an ambitious goal: to repair a bomber a day. B-24 bombers had previously been repaired at one dock, but the maintenance unit wanted to see if a production-line setup was more efficient. The B-24s were now moved from one station to the next for repairs. By July, they had achieved their goal and, later that year, received national attention as the first production line for B-24s. (Courtesy of Hill Air Force Base.)

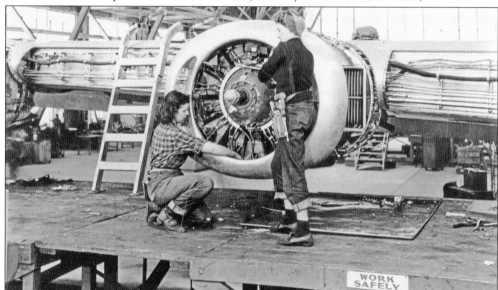

While most women were drawn into the work force by a sense of patriotic duty, they also enjoyed the benefits of their employment. Women were paid well at Hill and other installations, and for the first time, many had money of their own. Men and women at Hill worked around the clock to repair aircraft structures and engines, but even with the long hours, many women found a new sense of freedom. (Courtesy of Hill Air Force Base.)

Easy access to railroad lines was one of several reasons the federal government chose Weber and Davis Counties as the site for so many military installations. The Ogden Air Depot (later Hill Air Force Base) had 14.2 miles of railroad, and large quantities of materials could be shipped quickly. In the first four months of 1945, personnel loaded 3,240 freight carloads of materials.

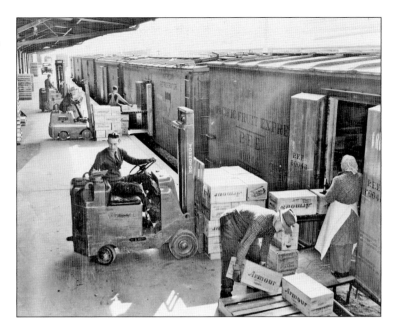

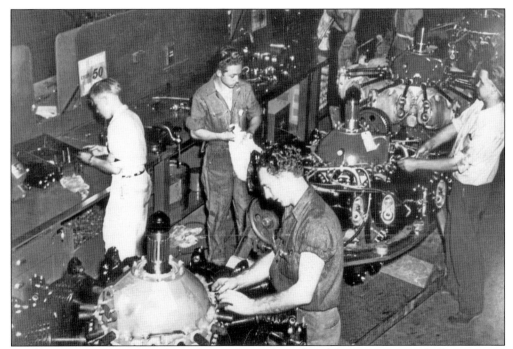

In addition to repairs on aircraft, employees also performed modifications on aircraft, their engines, and other equipment. These complicated tasks required a great deal of training. A program was developed with local vocational schools. Trainees began as mechanic learners, then progressed to mechanic helpers, with their salaries increasing from $50 a month to $110 a month. (Courtesy of Hill Air Force Base.)

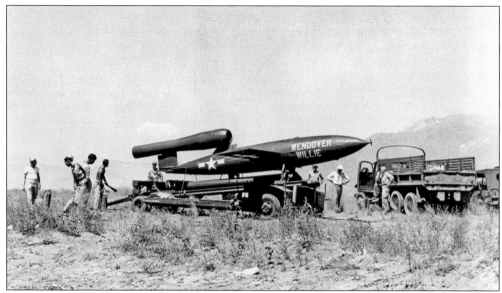

The JB-2 bomb was the US Army's version of the German-made V-1 "Buzz Bomb," a pilotless flying bomb. In 1944, salvaged German parts were analyzed in Britain and the United States, and the JB-2 was developed. Flight testing to improve the guidance system was carried out in Florida and Wendover, earning the bombs the nickname "Wendover Willie." Production stopped in September 1945; only 1,385 JB-2s were completed and delivered to the War Department. (Courtesy of Hill Air Force Base.)

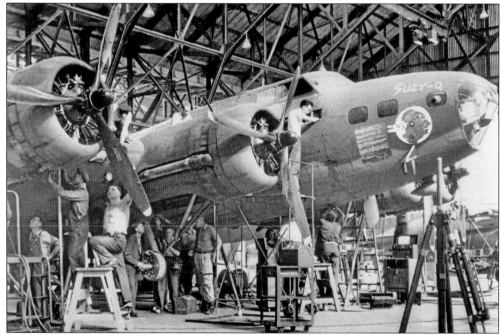

Named after his wife's nickname, Maj. Felix Hardison flew the *Suzy-Q* around the globe in several missions, and the aircraft became one of the most famous during the war. *Life* magazine even called it the "Fightingest Flying Fortress." The *Suzy-Q* arrived at Hill Field in July 1943 for repairs, and crews worked quickly to send her on her way by September. (Courtesy of Hill Air Force Base.)

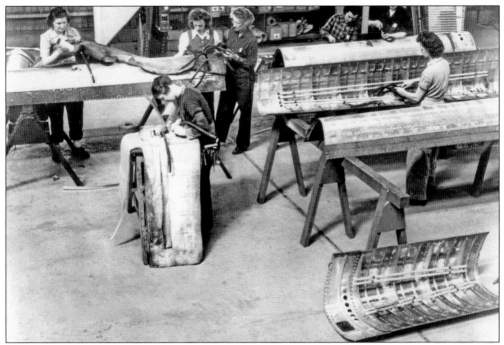

As Hill Field grew, construction couldn't keep up with demand for new work spaces. The Army Corps of Engineers reported that in one instance, crews were repairing aircraft in a hangar before construction on the building was even complete. Construction did not end until January 1942, but despite this, work continued at incredible speeds. (Courtesy of Hill Air Force Base.)

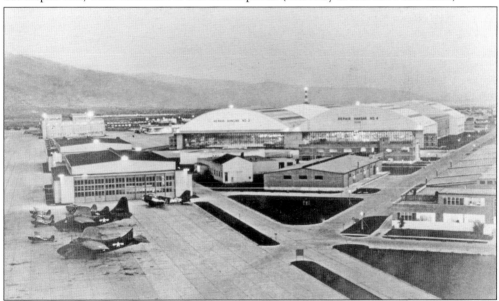

The high workload kept employees working long hours. In this photograph, the base lights have come on at twilight as the swing shift works in the shops and hangars. One project in particular, defrosting and repairing surplus planes stored outside during a bad snowstorm, had employees working day and night, well beyond their regular shifts, for months on end. (Courtesy of Hill Air Force Base.)

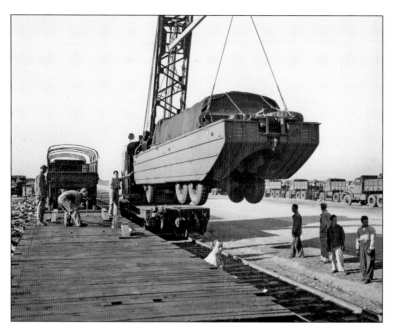

Beginning in 1942, employees at the Ogden Arsenal also serviced and shipped military vehicles in addition to their work on munitions. Thousands of vehicles passed through the arsenal, such as this truck being loaded on a train car. Utah's dry air provided an excellent storage environment for the vehicles.

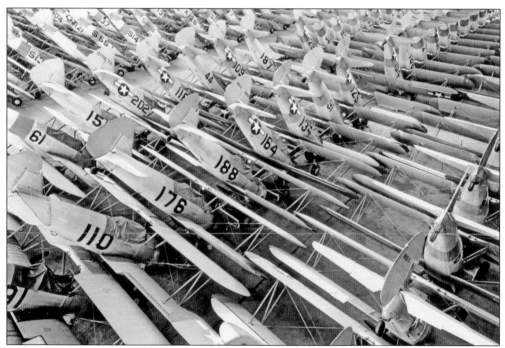

In 1946, Hill Field was no longer repairing aircraft, but was instead storing them. These PT-13 Stearman trainer airplanes began arriving for storage in September 1945. By the end of the month, they had received 124 of these aircraft. The large number of planes were stored in this unusual fashion. (Courtesy of Hill Air Force Base.)

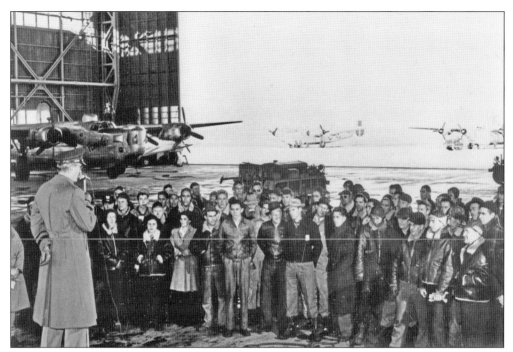

As the war drew to a close, operations at Hill began transitioning from repairs and maintenance of wartime machinery to the disposition of surplus machinery. Brig. Gen. Ray G. Harris arrived in the fall of 1945 to oversee this transition. Soon after, he gathered maintenance crews to commend them for their excellent work. He stayed at Hill Field until he retired in 1947. (Courtesy of Hill Air Force Base.)

Military and civilian personnel at the Ogden Air Depot work hard in their duties as they drive for victory. From left to right, Donald Ransomer, Pvt. Jack Hyde, and Jean Gillies practice the disassembly of an Army bomber radial engine at the post schools offered at Hill. The same crew worked on Allison liquid-cooled, in-line aircraft engines.

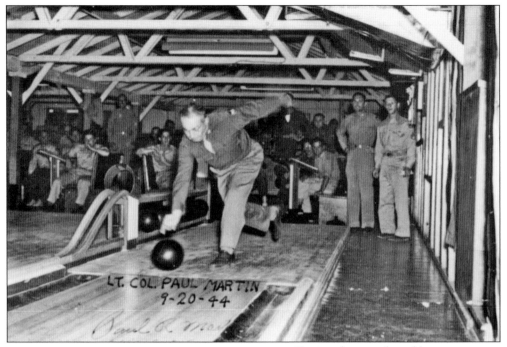

LT. COL. PAUL MARTIN
9-20-44

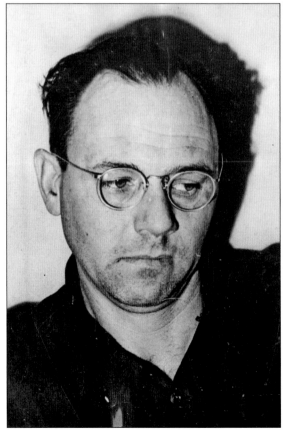

During the war, the soldiers needed downtime. Some of the recreational activities available included bowling, baseball, and watching basketball games against the Harlem Globetrotters. Seen here is Paul Martin, who is taking a break from his duties of dealing with the rise of venereal disease among Hill Field soldiers. He retired from active duty in September 1945 after serving three years at Hill. (Courtesy of Ogden Union Station.)

James Burke was arrested in early January 1944 for the theft of 13 vials of a deadly radium solution from the instrument repair section at Hill Field. Burke kept the vials in his shed at home until he became too scared a few days later. He chose to return the items by mailing them back to Hill Field. He claimed that he did not know why he took them. He was charged with unlawful mailing and theft of government property.

Five

EVERYONE'S GOT A HAND IN THE FIGHT

DDO AND CLEARFIELD NAVAL SUPPLY

In 1940, the US government asked many Harrisville families to sell their homes and farms in order to establish the Utah General Depot (UGD) on the west end of Ogden. The depot served as a general warehousing facility and soon became the largest quartermaster depot in the United States, with five million square feet of enclosed warehouses and an additional thirteen billion square feet of open storage space. During 1943, the depot employed 7,700 civilians and shipped over 200 train carloads of materials per day. As with Hill Field and the arsenal, the Utah General Depot was on inland space with access to the Union Pacific Railroad. Unlike other defense facilities being hastily constructed during World War II, the Defense Depot Ogden (DDO) would become a permanent military installation, operating until 1995. The depot included a quartermaster section supplying clothing, rations, and helmets; a signal supply section supplying radio and electrical equipment; a chemical supply section shipping chemical weapons; an ordnance supply responsible for the construction of shipping containers; and the transportation section, which housed trains, tanks, and artillery pieces. The depot employed women, local high schoolers, and even college students from Logan to help alleviate the shortage of workers during the war.

In 1942, an act of Congress authorized the acquisition of land in Clearfield for the construction of the Navy's largest inland supply depot. It was chosen because it was equal distance from Los Angeles, San Francisco, and Seattle. The area also provided access to two transcontinental railways and ample air and trucking facilities. Construction on the Clearfield Naval Supply Depot (CNSD) began in June 1942, and the first shipments were received by December of that year. The depot served as a giant storehouse area for the entire Pacific fleet. It housed and repaired equipment needed for the naval ships, including rudders, electrical components, and guns. Personnel at CNSD included women of all ages, and men young and old. Often, entire families from the area worked in the warehouses. The depot stored over a half million different items and sent out over 4,000 train car loads each month. There were 8,000 employees who covered the three rotating shifts so that the depot never closed during the war.

When the Ogden Chamber of Commerce began working to bring military installations to the Ogden area, they organized a finance committee. Members included George S. Eccles, H.E. Hemingway, Frank M. Browning, and Samuel C. Powell. In only 10 days, the committee raised $100,000 to purchase land for what would become Defense Depot Ogden. Pictured here is Samuel Powel (left) celebrating the depot's anniversary with Col. Robert Ladd, commander of the depot from 1967 to 1971.

In November 1940, the military began surveying the site of the depot for preliminary work on the roads. At first, four miles of roads were paved with the main entrances at Second and Twelfth Streets. By 1941, the compound needed to build eight more miles of roads to accommodate the 41 buildings completed or under construction.

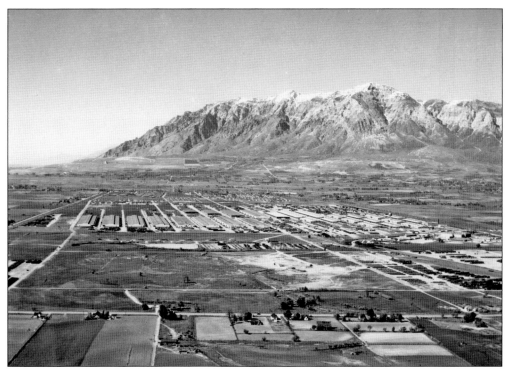

The depot started with 8 original warehouses but expanded to 28 during the war. The warehouses shipped 200 boxes a day and handled more supplies than the other three Utah depots. The warehouses shipped supplies to the war zones through ports on the West Coast. The depot housed material for storage and disposal after the war.

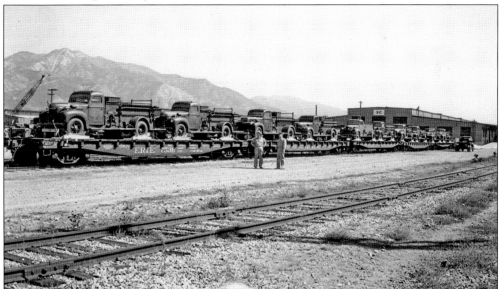

Shown here are 14 train cars full of fire engines that are being shipped to Japan for fire protection of military installations there. Lt. Col. Edward Gill (left) and G. Lamar from the Utah General Distribution Depot in Ogden are inspecting the shipments before they are sent overseas. The engines were treated for protection during ocean shipment.

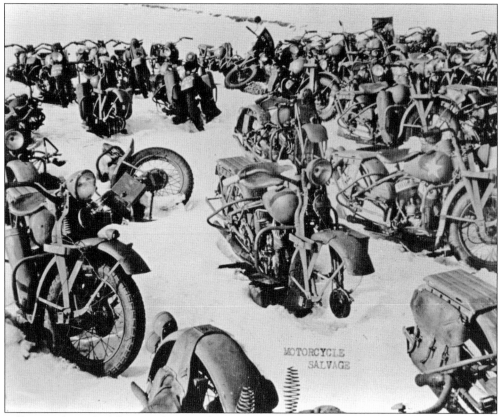

Following the end of the war, there was billions of dollars of surplus war property that needed to be disposed of. In 1946, the US government allowed for certified World War II veterans to buy certain items that could be used for personal, business, professional, or farm uses. The surplus included jeeps, trucks, motorcycles, passenger cars, tractors, construction equipment, plows, medical equipment, and typewriters. Shown here are some of the excess motorcycles that were stored on Twelfth Street.

In March 1943, the civilian dormitory for single women was opened at the depot. It housed approximately 700 women. There were three lounges where the women could meet their friends, and mess halls for their meals. A double room rented for $8 a month, and a room shared by four was $6 a month.

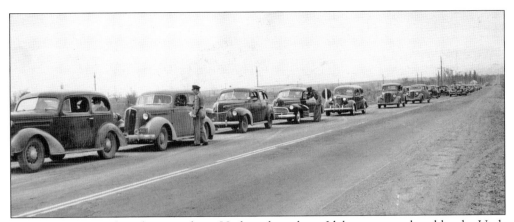

Over 1,200 war workers from northern Utah and southern Idaho were employed by the Utah General Depot. In order to help eliminate the long lines of cars waiting to get onto the depot grounds, the War Department started a mass transportation project. The project included 26 buses that served as far north as Preston, Idaho, and ran to accommodate all three shifts. The buses helped to save over 40,000 car miles per week.

Pictured here from left to right are Lou Molding, Lena Wilson, and Thelma Thompson. These women began working at the depot in 1943 and worked with the Italian and German POWs in the warehouses. There were very strict rules from the military, as the POWs were not authorized to talk to anyone except in the performance of their duties. They prohibited fraternizing, exchanging of gifts, letters, messages, and other items not in accord with work orders. (Courtesy of Ogden Union Station.)

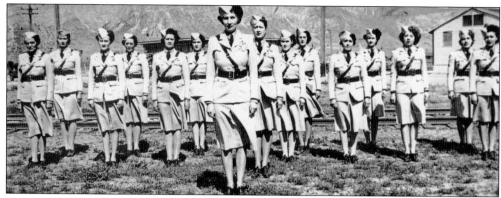

During World War II, the Women's Auxiliary Army Corps was established. The 9th Service Command was created for the enlisted women in Wyoming, New Mexico, Colorado, and Utah. The Utah General Depot was the regional distribution depot for the supply of enlisted women's clothing and equipment for the entire 9th Service Command. Seen here are a group of WACs in formation on the depot grounds.

These are the personnel of the medical section at the UGD. In the third row at right is Giuseppe Battisti, an Italian prisoner of war who served as a messenger for the section. He met his wife, Cleone, at the depot. He did not need to deliver orders to her floor, but often did to see her. The couple had to be careful to not be seen together, as it was against orders.

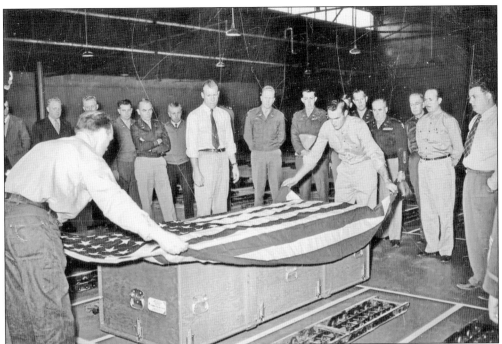

In 1947, the return of America's war dead from overseas burial plots to their final resting places in the United States was completed. Utah General Depot was one of 15 centers that had been set up to receive the bodies destined for their next of kin in Utah, Wyoming, Nevada, Colorado, Idaho, Montana, and Oregon. The care and specific planning used in the handling of the bodies assured there was no chance of mistakes. Below, Maj. Steven Capasso explains the process of the first inspection of the shipping cases to the press and representatives from other bases. The cases were painted and repaired if necessary. Above, Orson Foulger supervises the placement of an American flag over a shipping case.

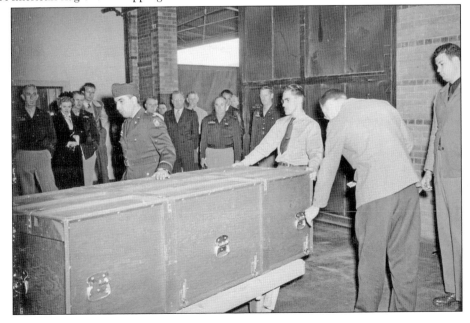

Military police patrolled beats to keep order wherever servicemen were found. In 1943, the military moved to consolidate all police activity in the Ogden area under Brig. Gen. Ralph Talbot Jr. at UGD. The local unit had 75 officers who worked with local police. They also patrolled the POW camps to keep the prisoners in line. This included escorting the prisoners to worksites to ensure no escapes.

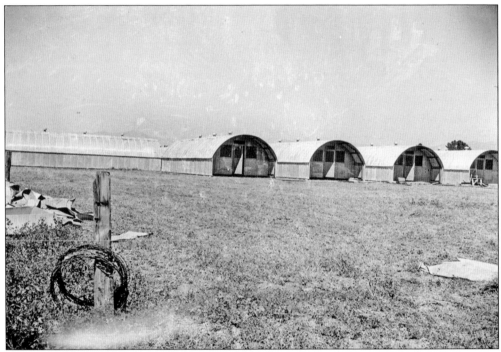

Leaders at Clearfield Naval Supply Depot looked for creative solutions to solve the housing shortage their employees faced. Based on Nissen huts used during World War I, Quonset huts could be built quickly and were flexible structures. They could be used as temporary offices or provide living quarters for about 12 people. The first Quonset huts at the Naval Supply Depot were completed in August 1942. Overall, the huts provided housing for about 1,800 victory workers. (Courtesy of Utah State History.)

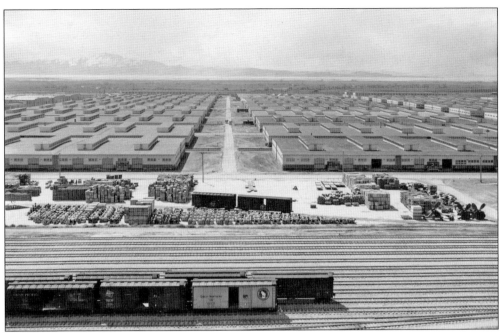

Clearfield Naval Supply Depot was commissioned on April 10, 1943. When it was commissioned, it was the second largest naval supply depot in the world. By the end of World War II, it had become the largest. In 10 months, 48 warehouses were constructed, along with 30 miles of railroad and 14 miles of road. The staff included 5,000 civilians and 2,000 military personnel.

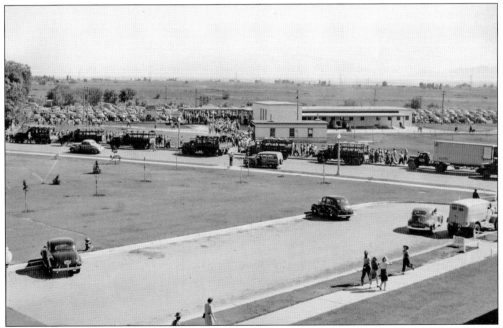

When the supply depot opened in 1943, the facility faced a shortage of personnel. The call was answered by many including elderly men, women, war wives, high school boys, and girls right out of college. Whole families would come and work throughout the depot. Personnel rode buses from various areas of the depot to the front gate at the end of their shifts.

After the Navy picked Clearfield as the site for a supply depot, The US Naval Oceanographic Distribution Office moved into the new buildings. The office was established to maintain a supply of navigational instruments and nautical charts. Seen here are a group of employees beneath a sign reading, "Hats off to Hydro," in celebration of the US Navy Hydrographic Office.

Over 30,000 spare parts were stocked for automotive equipment at Clearfield Naval Supply Depot. The parts included 400 models of 51 makes, 10,000 parts for materials handling equipment, and 500 items of related accessories and ship equipment. The automotive group serviced approximately 250 naval activities in the United States and numerous advance bases and ships.

With so many women in the workforce during the war, employers faced new challenges. A significant absenteeism problem at the supply depot prompted leadership to discuss with women the reason for their missed shifts. They discovered that many women had to skip their shifts to do their grocery shopping before stores closed. Depot leaders arranged for longer store hours with local shopkeepers, and absenteeism was reduced.

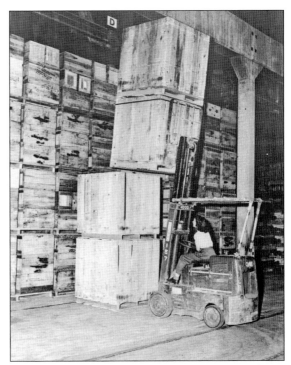

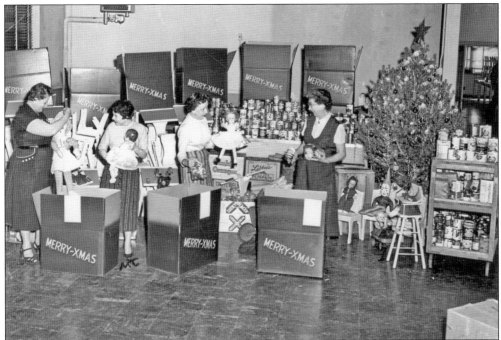

When the supply depot began hiring, it first reached out to the local community and the response was immediate. A history of the depot noted that "The call was answered by many, elderly men, mothers, war wives, girls fresh from college, high school boys who worked after school." Not only did they help the war effort by working at the depot, they also helped those in need. This group is gathering and sorting toys for families affected by the war.

Shown here is just one of the 1,100 sailors doing duty at the depot. He is peeling the protective plastic wrapper from a ship's spare part. The part was dipped in "plastic soup," containing just enough oil to make the peeling come off when it reached its destination. Dried in less than a minute, the covering preserved the part against rust and other forms of corrosion.

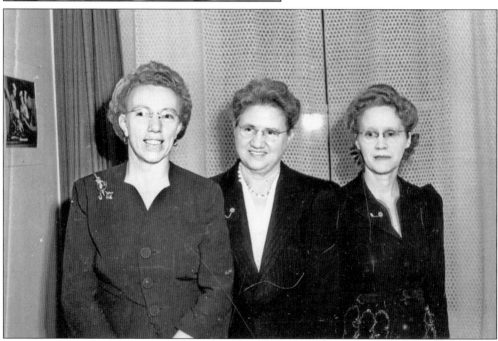

The Navy Mothers' Club was created at the supply depot to promote friendly and social relationships between the parents of men and boys in the Navy or Marines. The club collected information relating to the Navy, promoted the organization, and communicated with other mother's clubs all over the United States. Any mothers having boys in the Navy or Marines were welcome to join. Pictured here are, from left to right, Mattie Strebel, Nellie Hock, and Eva Nielson.

Six

THE ENEMY IS CLOSE
POW CAMP

With the United States advancing against the Germans and Italians, the government faced a problem of quartering, maintaining, and utilizing enemy prisoners of war. On October 11, 1942, an order was issued that authorized the establishment of POW Camp Ogden for the purpose of supplying unskilled labor to Utah General Depot. Almost immediately, the officer's quarters, guard quarters, warehouses, station hospital, compound No. 1, and athletic field were constructed. In 1943, camp headquarters, theaters, recreational hall, fire station, and compound No. 2 were constructed.

Camp Ogden was activated in December 1942. Each of the compounds held eight POW companies of 250 men each. The Italians arrived from April 1943 to February 1944. A total of 4,657 men were interned in Ogden. Most of the soldiers were captured in North Africa and Tunisia. They were clothed and given medical care. Each man was provided with the US field ration, with an increase in pasta and rice for the Italians. Germans arrived in August 1944. There were 2,950 Germans housed at Camp Ogden. They were given their own compound to keep them away from the Italians.

The prisoners were allowed to attend religious services. They had recreational activities such as games, sports, a band, and an orchestra. All of the men were authorized for labor. They worked in warehouses, canning factories, and food processing plants. Some of the men with training in skilled trades were allowed to work as tailors, cobblers, and woodworkers. The men provided services to not only their fellow prisoners, but also the military stationed at the depot. The POWs were requested to stay away from the women at the depot and not engage in any trade or conversation with people working. This became difficult after Italy surrendered and the men were given more freedom. Many of them ended up marrying girls who worked at the depot, and returned to Utah after the war ended.

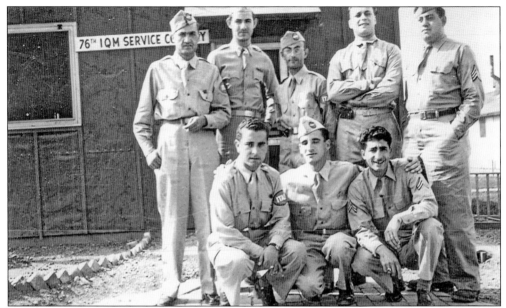

Once Italy surrendered during the war, the prisoners of war held on US soil were converted into Italian Service Units (ISUs). Pictured here are the men in charge of the 76th Internal Italian Service Unit. From left to right are (first row) Lt. Charles Malta, Lt. Ghiloni, and unidentified; (second row) Lt. John Rice, Lt. Domenico Greco, Capt. Antonio Pisano, ? Modafferi, and Lt. Pietrangeli. The men were responsible for keeping the records of the prisoners, including reports and any other information the Army needed.

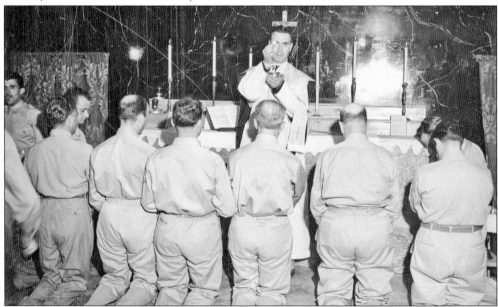

The prisoners of war were able to attend religious services every week. Fr. Raphael Monteleone was the post chaplain who provided Catholic services for the ISU at the depot, Hill Field, and arsenal. He was the first to provide services to the Germans as well. The first Sunday, 760 prisoners out of 1,250 attended the mass. The attendees grew to the point where mass was held in the recreational hall to accommodate 1,300 prisoners.

William Lawler was a sergeant of the guard at the POW camp from July 1945 to August 1946. He had to search the prisoners when they came back to camp. During these inspections, he found all kinds of things including candy bars, spoons, and knives hidden in boots or under shirts. His wife, Allie, worked in the stockroom where she was in charge of the box makers and janitors.

Carl Fernelius was drafted into the Army in June 1943. He was assigned to the depot as one of the many military police officers. He was assigned a daily detail of 10 to 25 prisoners. He marched them to the warehouses or wherever they were needed. With the Italians, he was in charge of keeping track of the prisoners and trying to keep them away from the American girls. Carl is pictured here with his wife, Lorna.

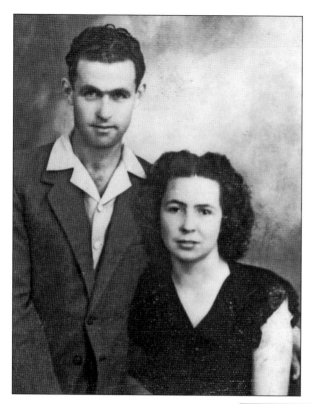

Giuseppe Giordano was one of the hundreds of thousands of Italians captured by the Americans in North Africa. He arrived at Camp Ogden in 1943. He talked about having all the food they could eat at camp. The Italians even formed their own cafeteria and made their own bread and pasta. He met his wife, Beth, at the depot. She worked in the warehouses and he made sure that he was always the messenger who picked up her packages. They were married in 1946 in Italy.

Erich Kosisk was a German soldier captured in 1944 and sent to Camp Ogden that same year. At the camp, he was trained as a medic and was responsible for giving shots to the prisoners. He was able to attend English classes as well. His family back home was not aware of his capture until a few months before his release, when the Red Cross informed them. He was released in 1946 and returned home.

Each company of 250 Italian prisoners was led by an American officer, first sergeant, and company clerk, and one Italian non-commissioned officer. Some of the Italians, known as "Black Shirts," remained loyal to Mussolini even after Italy surrendered. They refused to join the Italian Service Units and were sent to Idaho. Most of the prisoners, however, were happy to be in the United States and enjoyed the relative freedom they were given.

Behind the double fence was the station hospital and dispensary. The hospital opened in March 1943 with a 100-bed capacity. It was later expanded to include 40 more beds. Various infections and injuries were treated in the hospital and some dental care was given as well. When porcelain fillings became available, about 500 were completed a month.

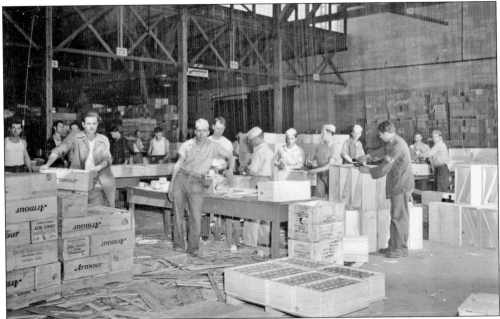

The standard POW uniform at the camp was made of dark blue denim. As prisoners arrived, they discovered that not enough blue shirts were available, and sufficient dying facilities were not available in the state. Using salvaged oil barrels and wooden barrels for rinsing, a dying plant was improvised. A team of 13 prisoners dyed 13,000 articles of clothing by October 1943.

The POW camp included four theaters: two with a capacity of about 300, and two with a capacity of 500. Prisoners could watch movies with Italian subtitles, and put on their own vaudeville shows and other theatrical performances. They not only entertained their fellow prisoners and employees of the depot, but many of Ogden's citizens would also visit the camp theaters as well.

A 28-member band was organized at the camp in May 1943. Instruments were donated by the Catholic church or loaned by the quartermaster, and concerts were given once a week. Ogden High students sometimes performed with the band at these concerts, which were also popular with the community. The prisoners also organized an orchestra, which gave a concert once a month.

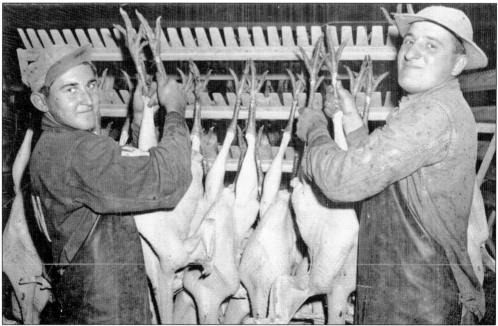

Because of labor shortages, both Italian and German POWs performed all kinds of agricultural work in Ogden and the surrounding communities. Often, they worked at private farms and orchards helping farmers harvest their crops, but these German prisoners are working at the Utah Poultry Producers Cooperative Association plant in Tremonton, Utah. Using POWs for this kind of labor freed local citizens for work more directly related to the war effort.

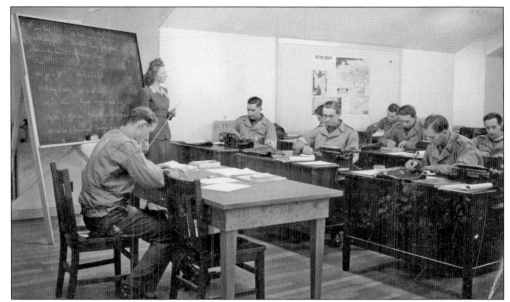

When not working at the camp or offsite, German and Italian prisoners were able to take classes in English, typing, and other subjects. A library was also opened at the camp with the help of the YWCA War Committee. Ultimately, the library had about 500 volumes available, as well as newspapers and magazines. Prisoners joined these classes enthusiastically.

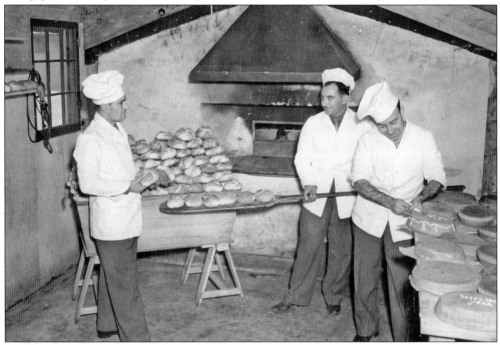

Prisoners at the camp were well fed. The camp history reported that prisoners gained an average of 15 pounds while there. Prisoners were given typical food rations, but visitors were amazed at what they were able to cook with those rations. Robert Busico worked at DDO during the war and recalled that their bakery was immaculate, and he felt honored to be one of their many guests at meal time.

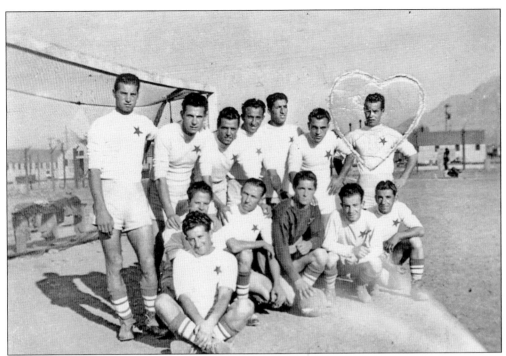

Each of the two compounds included an athletic field, and prisoners were provided with equipment for a variety of sports, including baseball, football, and soccer, which was the most popular. Guiseppi Batistti (second row, far right) is pictured with his soccer team. He and his teammates sometimes traveled to Salt Lake City for competitions. The prisoners were also given games like checkers, dominoes, and playing cards to keep up morale.

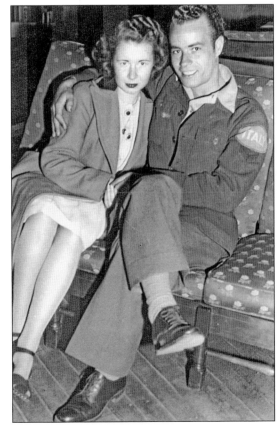

Cleone Bateman worked at DDO, where she met Guiseppi Batistti, an Italian prisoner. Cleone recalls one visit in particular: "We went back to the auditorium and it was packed. But they all moved around so we had a seat there. Someone from behind said, 'Hey Giusep, who's the girl?' He said, 'She's going to be my wife.' That was the start of it." After the war, the two married in Italy and eventually settled in Ogden.

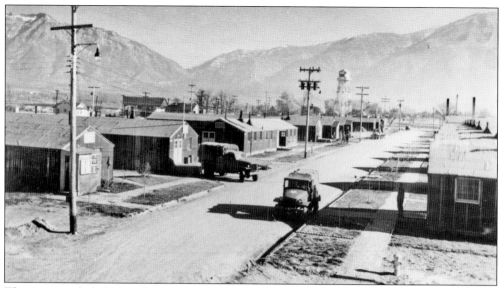

The camp included barracks for the guards. There were also six guard towers equipped with machine guns and manned 24 hours a day. Guards also accompanied prisoners on work details and patrolled the perimeters. Although security at the camp was taken seriously, it seems that there was not much concern about prisoners acting up. Although Army regulations required one guard per 10 soldiers, as many as 32 prisoners were assigned to a guard.

Many of the first German prisoners to arrive were actually from German-occupied countries and had been forced into military service. Later contingents were more committed to Nazism and began causing problems at the camp. Guards noted that they were arrogant and intentionally wore their German uniforms to intimidate other prisoners. These uniforms were confiscated, to be returned later, and curfews were instituted. This helped to eliminate the problems.

Seven

WHAT ARE YOU DOING TO HELP

THE RED CROSS

The Red Cross had a twofold task during World War II. The first was to provide services to aid the morale of the armed forces and safeguard the life and health of the civilian population. The organization worked to mobilize all men and women to take training in first aid and accident prevention so that every city block had a trained first aider. The Red Cross also requested blood donations from every healthy person between 21 and 60 years old to help the wounded soldiers overseas.

On the home front, the Red Cross organized the Volunteer Special Services. These included nurses' aides, the "Gray Ladies," canteen, and motor corps. All members of the services wore specific uniforms upon training and qualification.

Of all the Red Cross services, the nurses' aides section ranks as one of the most important. The women worked as assistants to professional nurses in hospitals and clinics. They were responsible for making beds, giving baths, assisting with dressings, and making the patients comfortable. The Gray Ladies, named for their gray uniforms, were also stationed in hospitals. These women had to have a cheerful disposition and were qualified to build up the morale of the sick. The ladies entertained convalescents, acted as hostesses in clinics, read to the sick and wounded, amused children, received new patients, and worked in the hospital libraries.

The Canteen Corps was charged with feeding the civilian population in a disaster and troops in transit or doing special duty. The Weber County chapter opened a little brown hut in Union Station to feed the troops as the trains rolled in. The women provided coffee and a hot meal for the troops. Since trains were coming through at all hours, the canteen was open long hours each day. The aim of the Motor Corps was to furnish economical and efficient transport whenever and wherever it was needed. Anyone between 20 and 50 years old was able to join once they met the health and fitness requirements. The women had to give a minimum of 15 hours service a year and attend 35 hours of first aid and motor mechanics training.

The canteen at Ogden Union Station was one of the busiest in the pacific area. By January 1943, they had already served 103,634 service members and had 92 workers who logged 1,637 hours of service. The ladies offered more than just cookies, donuts, and coffee. They added sandwiches, hot biscuits, and cinnamon rolls to the menu from 1942 to 1946. Pictured here are, from left to right, Florence Nebeker, Maude Porter, and Cleona Hedenstrom.

The canteen served 1.6 million servicemen during World War II and only closed for half a day on the day of Maude Porter's husband's funeral. On VE Day, the canteen served 2,047 people. Porter wrote, "The stores are closed but our boys are here in large numbers to be served." After V-J Day, the women realized the canteen would not remain open much longer, but looked forward to serving the returning soldiers.

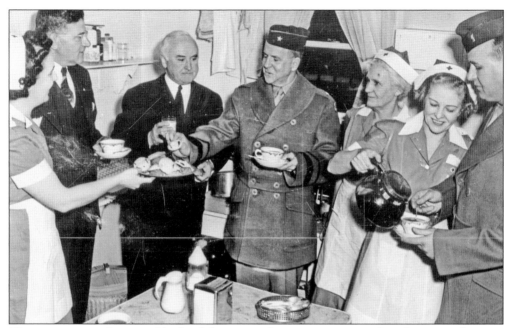

The canteen was also visited by local dignitaries during its operation. Seen here are a few men sampling the refreshments and coffee supplied by the ladies of the canteen. From left to right are Roger Edens, superintendent of the Ogden Union Railway & Depot company, which equipped the canteen; Elbert Bennett, president of the First Security Corp and chairman of the Weber County Red Cross; Ralph Talbot of the Utah Quartermaster Depot; and Lt. V.L. Lewis, public relations officer at the depot.

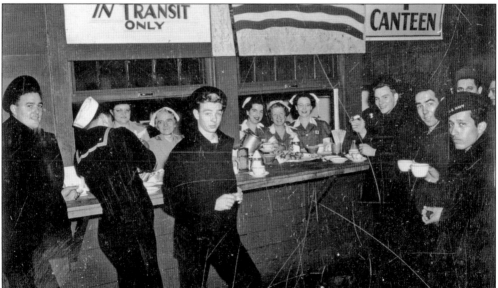

The canteen workers loved serving and visiting with the servicemen, many of whom were happy to help the women in return. During rushes on the canteen, soldiers volunteered to wash dishes and pass food through the window. When the canteen closed on January 3, 1946, the volunteers wrote, "[I]t is with reluctance that we close our door and contemplate that a pleasant service is ended. A salute to the uniformed friends we have known."

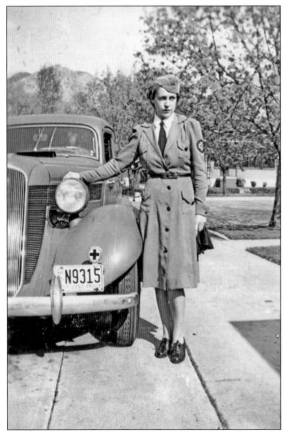

Maude Porter and her nearly 200 volunteers ran their "little brown hut" with good cheer and efficiency, impressing many. One Ogden soldier wrote home to say that the soldiers he met were well pleased with the canteen's service. Detailed log books were also kept, listing donations, hours worked, and men served. In the book pictured here, visitors were able to sign in and note where they were from.

Arvilla Hodgson became a captain for the Red Cross Motor Corps during the war. She drove a truck that could be converted to fit four stretchers to carry the wounded. She had one man who she was to transfer from Bushnell Hospital to the Veteran's Administration (VA) hospital in Salt Lake City. The soldier passed away on the way down. Arvilla was stuck, as the VA hospital would not accept the dead soldier, so she had to drive him back to Bushnell.

The Red Cross Volunteer Nurses' Aide program first saw service during World War I. The program trained young women to assist nurses who were being bombarded with injured soldiers and desperately needed assistance. During World War II, the program was reinstated, with over 212,000 aides volunteering their services in military hospitals.

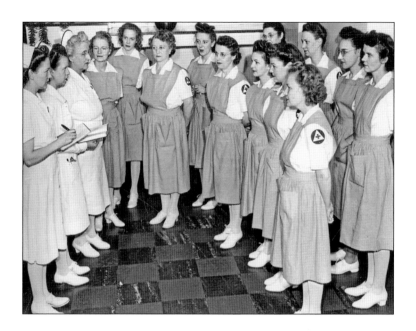

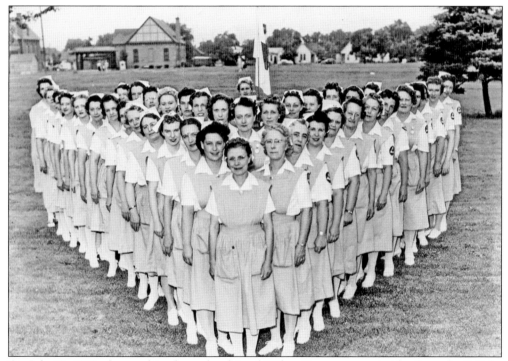

On July 12, 1942, the combined membership of Weber County nurses' aides formed a "V" for victory. By 1945, over 42 million hours of service by the aides were completed. The volunteer women aged between 18 and 50 performed nontechnical work in over 2,500 civilian and military hospitals across the country.

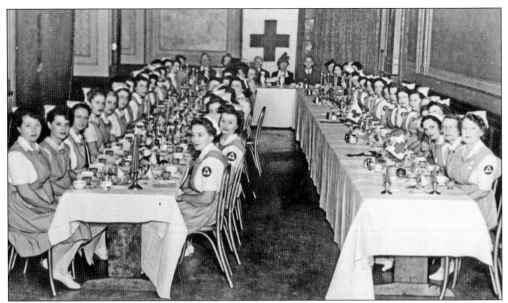

On December 31, 1944, a holiday dinner was held at Dee Memorial Hospital to honor the nurses' aide corps. It was a fitting tribute to the women who had so faithfully assisted in nursing at the hospital and at Bushnell. A toast was given by Arline Johnson: "Here's to the aides, to the nurses, who work without filling their purses. They carry out cans and have bedpan hands, but get more of praise than of curses!"

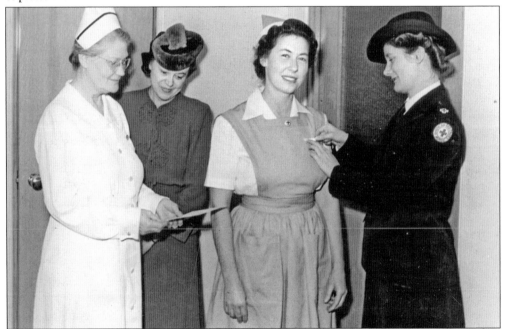

For completing 150 hours of volunteer service in just 18 days, Ellen Irene Gingrich received the nurses' aide white bar. She was awarded the bar by, from left to right, Oetta Glasscock, director of nurses; Irene Diehl, chair of the nurses' aides; and Lois Goodman, Red Cross nursing consultant. Ellen was the first in the four units to complete her service in such a short time. She stated that she wanted to accomplish 500 hours.

Throughout the war years, Weber County conducted Red Cross drives to help raise funds that would be used both at home and abroad. Shown here are Gene Robinson, general chairman, and Olin Ririe, chapter chairman. The drive was hoping to reach a quota of $44,865, with the military divisions, public employees, women's clubs, and contractors being the top four money raisers.

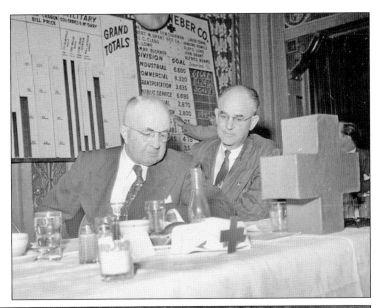

During the 1940s, 100 percent of students in Weber County and Ogden City schools enrolled in the Junior Red Cross. By 1943, about 1,750 students were first-aid certified, 3,000 were lifesaving and water-safety certified, and 25 earned home nursing certificates. The students were involved with making Christmas boxes and comfort kits for servicemen. They also raised $350 for fracture equipment to be used at the station hospital at Hill Field.

Ogden High School junior and senior girls were all Red Cross certified during the war years. Seen above are some of the students learning to tie bandages in the auditorium. Over 660 girls learned first aid during their physical education classes. They learned the basics of using different bandages, location of pressure points, and problems concerned with wounds. Over 198 girls completed advanced first-aid training. They learned more difficult procedures like traction splinting, as seen at left. They also were involved with the mock air raids that occurred around the city to man established first aid posts in the event of a disaster.

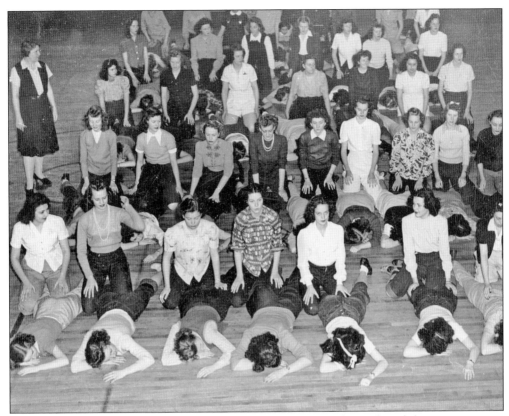

The Pep Club girls from Ogden High School were inducted into the civilian defense organization as messengers. They received training in war gases and fire control. They were assigned to assist the wardens in various blocks during air raid alerts and other periods of emergency. This was the first group of students used in this capacity in the country. Seen here are the girls practicing breathing techniques: "Out goes the bad air, in comes the good air."

Women throughout Weber and Davis Counties joined the Red Cross and were active in sewing clothing for soldiers and refugees. They knitted scarves, gloves, socks, and sweaters for soldiers. They made hospital shirts and robes for the wounded and clothing and layettes for refugee children. All these materials were sent to local military installations and overseas.

During the war, the Red Cross conducted the home nursing program to train women to meet any emergency including patient care and childbirth. The goal was to have at least one member of every family trained. The 12 lessons in practical nursing were taught to prepare women to cut down on the number of trained nurses needed outside hospitals. By 1944, the program was open to men and children as well.

The women of the Hospital and Recreation Corps were known as the Gray Ladies because of their gray uniforms with white collars and cuffs. The corps acted as hostesses and provided non-medical care to the wounded. To qualify, the women had to serve probationary periods of 24 hours in hospitals. Shown here are a group of probationers outside Bushnell Hospital in 1943.

The mobile disaster unit was a part of the Red Cross with people trained in the event of a disaster. The unit had its own electric generator or could be plugged in to the city wires. The truck also had a cooking stove, sink, water tanks, built-in tables and seats, four ambulance beds, and special cupboards for supplies. The unit was used in mock disasters and to set up hospitals and places for refugees.

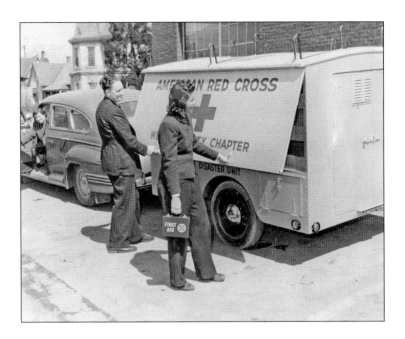

The Junior Red Cross at Ogden High School worked to gather clothing and other items for Greek War Relief. The group was able to gather several hundred pieces of clothing as well as 56 packages of toys and toiletries for children in foreign countries. They also gathered for the wounded soldiers as well by sending puzzles, magazines, and games weekly to Hill Field and Bushnell.

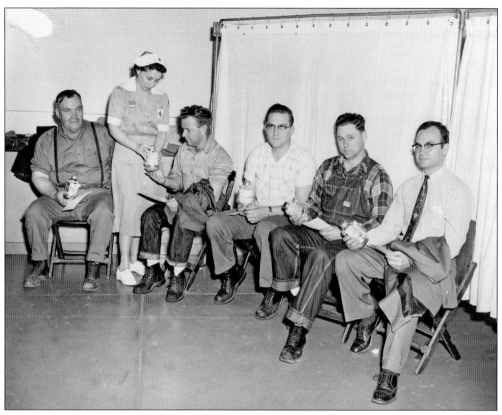

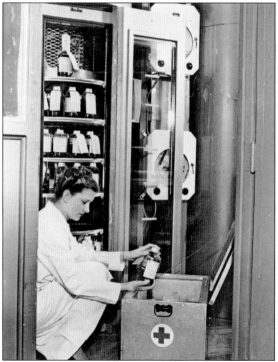

One of the most important campaigns run by the Red Cross during the war was the donation of blood and plasma for the wounded GIs. They pleaded with each man and woman to donate one half to one pint of blood. In 1943, the Red Cross was looking for 900,000 pints of blood, and the demand grew to five million pints the next year. Shown above are local men doing their part and getting ready to donate their pint of blood. At left is a technician packing the blood in refrigerated containers for delivery to the hospital, where it was used in treating patients whose recovery was helped by the availability of whole blood.

Eight

SOLDIERS WITHOUT GUNS
THE HOME FRONT

World War II was truly everyone's fight. It affected the daily lives of not only soldiers, but also the men, women, and children left behind. The citizens of northern Utah were involved in monthly drives for items needed for the war effort. The children from Mount Fort School collected 2,264 pounds of cans and 262 pounds of fat during January 1943. The fat was used in explosives and the cans for other strategic purposes. Even if a housewife only had a small amount of waste fats, she saved it for the war effort, as enough small amounts added up to a tremendous total. People collected waste paper and rags that were used to protect materials shipped overseas.

Bond drives were a quarterly event, with people expected to purchase bonds each paycheck. The bonds were issued by the government to finance military operations and other expenditures. People purchased $25 bonds for $18.75, and in 10 years, they were able to redeem them for the full $25. Children were even able to purchase war stamps for 25¢ and save up to help earn bonds.

As the war raged on, items that needed to be sent overseas were rationed. Meat, sugar, butter, gas, and tires were rationed and could only be purchased with stamps from each person's ration book. This allowed for the goods in short supply to be fairly distributed across the county. Much of the canned and processed foods were sent overseas for the military and allies. Women became creative with their meal planning to ensure there was no food waste.

Every citizen did their part for the war effort. High school students joined the Junior Red Cross and became trained in first aid to help in a disaster. Women knitted socks and gloves for "Bundles for Britain." Clothing was collected for the Red Cross to be given to the wounded soldiers and refugees. Women would spend their Saturdays rolling bandages for the war effort or getting involved in the civilian defense organization.

THE HOME TOWN

HI-BUDDY!

We Send You
BEST WISHES
and –

SEASONS GREETINGS

The soldiers from Ogden City were not forgotten during the holidays. In 1942, the city issued a call for the names of soldiers serving overseas. Each serviceman was sent a Christmas card from Ogden City mayor Harman Peery and the city commissioners. Over 250 names were given by October 26, 1942, and each received a little bit of love from their home town.

Kathleen Hadley was known as "Little Miss Pearl Harbor." She was born on Sunday, December 7, 1941, the day the Japanese bombed Pearl Harbor and launched America into World War II. She is the daughter of Marvin and Virginia Hadley. She is shown here in 1946 with a copy of the *Standard Examiner* issue from the day she was born.

On December 31, 1944, a Pacific Limited train with 18 cars full of military and civilian passengers crashed into the back of a Southern Pacific freight train on the Lucin Cutoff north of Ogden. In the crash, 48 people, 28 of whom were military, were killed, and over 100 were injured. The citizens of Ogden rallied by sending doctors, nurses, and ambulances to the crash site. Military installations in and around Ogden also responded to the call for assistance. A total of 75 soldiers from Hill Field were rushed to the scene in two buses. They worked throughout the day, recovering bodies of victims with the help of members from the naval depot and railroad workers. The hospital at Hill Field provided all its ambulances but one to help remove the injured and take them to area hospitals. (Courtesy of Ogden Union Station.)

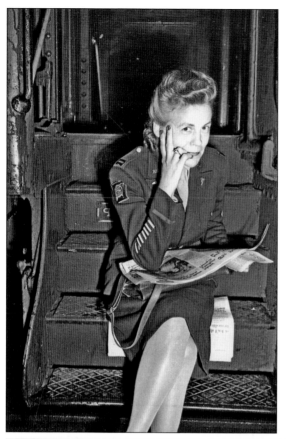

During May 1946, there was a massive nationwide railroad strike. The union wanted raises for the workers and changes to the working rules. The strike left thousands of people stranded and struggling to find other means of transportation. President Truman threatened military takeover of the railroads if the strike did not end. With the few trains running, only servicemen under orders were permitted to continue traveling. Seen to the left is Capt. Ruth Browning of the Army Nurse Corps, who served in Tokyo and had been overseas for four years. She was stranded in Ogden waiting to get home. She remarked, "First no air; then no sea; and now no trains." Thousands of bags of mail were stacked neatly on trucks, in cars, and under the sorting shed with little prospect of being moved until the strike ended. Below, workers wait until they can load the packages.

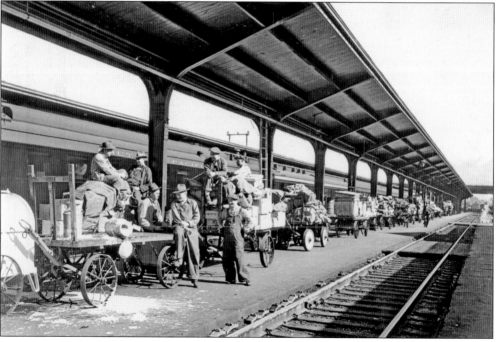

In 1943, the state of Utah started the Crops Corps volunteer program. With the labor shortage during the war, every man, woman, and student who could devote any time to working in the orchards or fields was called upon to save the crops. Between 600 and 700 Ogden boys and girls ages 14 and 15 were sent to the orchards to help with the cherry harvest. Local school buses would take the students to the orchards, and there would be one supervisor for every twenty students.

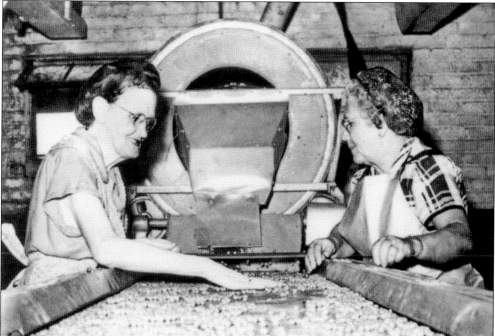

In July 1942, a call of distress came from the canneries of northern Utah. The factories needed two shifts of civilians to come and work the plant in Clearfield. The peas needed to be canned before they got moldy and unusable. During the campaign, there was a record day of 26,000 cases or 624,000 cans of peas completed in one day. The cases filled 15 train carloads. Polly Stimpson Staker (right) was just one of the hundreds who answered the distress call. (Courtesy of Ogden Union Station.)

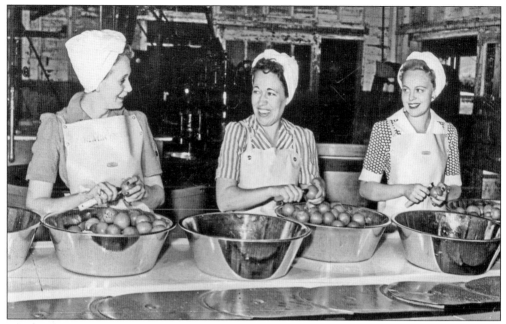

The harvest and canning of the crops began a job for all able-bodied people in northern Utah during the war. Volunteer workers at the canning plant are seen here preparing tomatoes for the canning process. From left to right, Lillian Tomlinson, Fay Piersanti, and Margaret Snyder, who were all associated with the Ogden Elk Does, volunteered hours to keep the plant going during 1943. (Courtesy of Ogden Union Station.)

During the war years, almost every boy at Ogden High School was part of the ROTC. The cadet corps prepared them for their eventual enlistment in the military. Ogden High had 470 cadets in the corps and an ROTC band. Seen here are, from left to right, Lt. Col. Carl Thorstead and Captains Herbert Mickelson, Boyd Knowles, John Baukol, and Hubert Erwin, along with their mascot, Skippy.

The girls of the Weber County High School Pep Club prepared packages for shipment to children in the war-ravaged lands of Europe. Each of the packages contained pencils, crayons, toothpaste, toothbrushes, washcloths, soap, and other needed items. From left to right are Dolores Bingham, Laverne Hunter, Doris Newman, Betty Pebley, Marian Clark, and Jan Campbell.

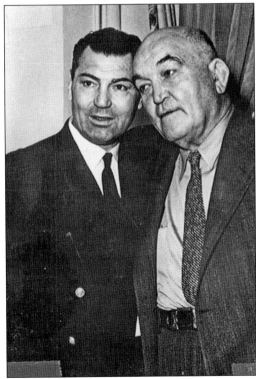

The Weber County war bond drive arranged for Jack Dempsey, former world heavyweight boxing champion and commander in the Coast Guard, to make appearances and pleas for war bond purchases. He is seen here on the left. Dempsey, also known as the "Utah Mauler," visited the depots and addressed the city at the victory bond house. He gave his time in the war effort and the sale of bonds. Dempsey stated, "Do your part by digging deep to buy the bonds to buy the equipment for the fighting men." (Courtesy of Ogden Union Station.)

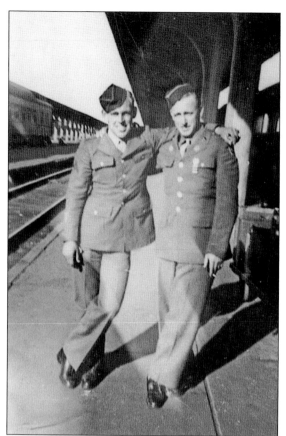

During the war, thousands of soldiers passed through Ogden on the train and stopped in the city. They often got off the trains to relax and have some fun. The soldiers did not care where they went, how they went, or when they came back. They could easily sleep in the aisles or anywhere they could curl up. Some looked for a place outside, away from the crowds and confusion.

Christmas was always an exciting time in Ogden's downtown shopping district as shoppers enjoyed window displays and other decorations. In December 1944, some retailers in the region expressed concerns about fewer shoppers, but Ogden's merchants reassured citizens and said there was "no letdown" in shoppers at their stores. This busy street corner scene at Washington Boulevard and Twenty-Fourth Street seems to support their claim.

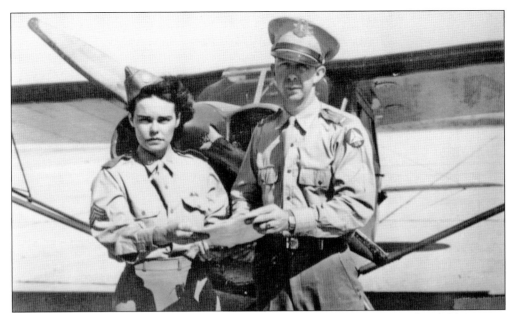

In 1942, Hinckley Airport was officially designated as a government approved airfield. Vincent McKay of the Civil Air Patrol and commander of the northern Utah group is pictured here with an unidentified female cadet. The group ran the airport during the war. They were responsible for keeping records of all planes using the field. No civilian planes were allowed to take off without meeting the requirements of the Civil Aeronautics Authority. (Courtesy of Ogden Union Station.)

Stores throughout northern Utah got involved in the war bond drives. Stores such as Lowe's Hardware in Ogden held a "merchandise bond" sale and sold over $6,000 in war bonds in just one day. Pictured here are people lined up at the bond counter in Woolworths to purchase their share of war bonds. (Courtesy of Utah State History.)

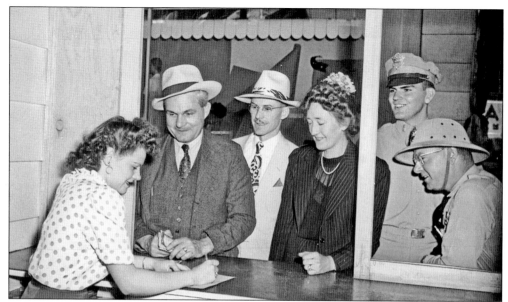

On September 9, 1943, Utah opened its third war loan campaign with a total of $1 million in bond purchases that day. The quota was $41 million during September for the entire state. In Salt Lake City, "bombs" were set off to signal the start of the campaign. War bond saleswomen manned windows throughout the business districts in the major cities. (Courtesy of Utah State History.)

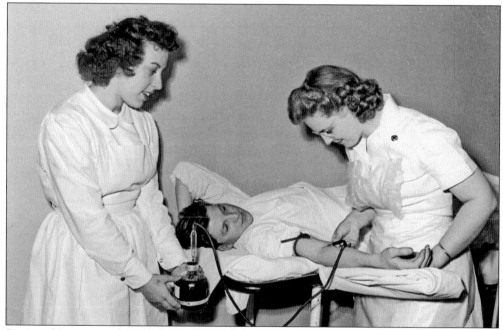

During the war, people pulled together and did everything they could for the war effort. The women's clubs in Ogden were no different. The Child Culture Club raised and donated $500 to the establishment of the blood bank at Dee Hospital. The new 14-room lab cost $50,000. Pictured here are, from left to right, Ann Crispin, LaMar Burnett, and Louese Burnett, registered nurse in charge of the blood bank.

In 1944, Ogden looked to raise an additional $350,000 in war bonds. The campaign happened during Pioneer Days in July. Each purchaser was given a postcard to mail to an Ogden soldier saying it was done on his part. Women's clubs solicited business and professional offices. There was keen interest in the "buy a bomber" campaign. It was successful enough to purchase a bomber for the military. In October 1944, the Utah Federation of Women's Clubs decided to attempt to raise $280,000 to purchase a Liberator bomber in two weeks. Every member of every club was to sell $100 in bonds. Each club got a certificate and photograph of the bomber that they helped to purchase as an acknowledgement of their support.

TREASURY DEPARTMENT
WAR FINANCE COMMITTEE

OFFICE OF STATE CHAIRMAN

Ogden, Utah

July 29, 1944

Mrs. Malcolm J. Pingree
2472 Custer Avenue
Ogden, Utah

Dear Mrs. Pingree:

We appreciate immeasurably your patriotic assistance in promoting the success of the Bomber Campaign for the "Ogden Pioneer Days". According to incomplete War Bond returns our campaign to purchase a bomber for fighting men of Weber County has been successful.

Thanking you again for your kindness, I am,

Yours very truly,

Carl C. Gaskill, Chairman
"Ogden Pioneer Days" Bomber Campaign

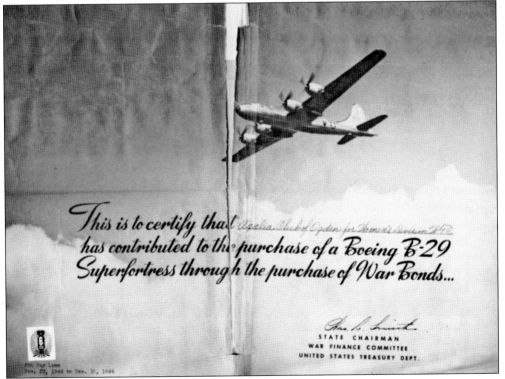

This is to certify that *Agalia Club of Ogden for Women's Division WFC* has contributed to the purchase of a Boeing B-29 Superfortress through the purchase of War Bonds...

STATE CHAIRMAN
WAR FINANCE COMMITTEE
UNITED STATES TREASURY DEPT.

In 1942, the motion picture *Iceland* opened across the United States. The movie tells the love story of an American soldier stationed in Iceland and his relationship with an Icelandic girl. It starred Sonja Henie and John Payne. The soundtrack included hit songs by Sammy Kaye such as "There will Never be Another You," "You Can't Say No to a Soldier," and "Let's Bring New Glory to Old Glory." Seen here are two girls promoting the film around town. (Courtesy of Utah State History.)

The citizens of Ogden worked together to have a drive for clothing and shoes to send overseas. Seen here are Rev. George H. Argyle, drive chairman, and Dorothy Warner, welfare office worker, surrounded by thousands of donations. People donated men's suits, coats, women's dresses, and shoes. All the items collected filled two 50-foot boxcars.

Due to the thousands of soldiers coming through Ogden on the train, a USO transit lounge was created at 109 Twenty-Fifth Street. Pictured here from left to right are Vernon Rhode, Dorothy Maher (hostess), Robert Ferola, and Dick Triggs. During Christmas, the lounge entertained over 200 servicemen with turkey sandwiches and entertainment. The citizens of Ogden donated small gifts that were handed out to the men.

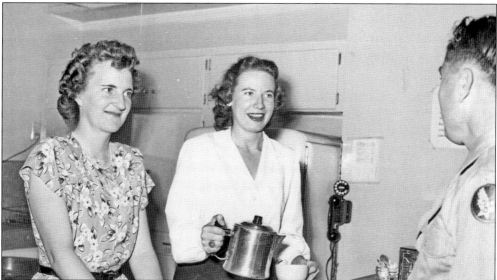

The USO lounge operated to accommodate the hundreds of teenage servicemen who passed through Ogden on a weekly basis as they were traveling to new bases. The boys needed the friendship, devotion, and good home-cooked food that the lounge offered every day. Eleanor Predovich (right) resigned director of the USO transit lounge, acquainted her successor, Lillian Lyman, with some of the tasks.

Waste paper drives were an important part of the home front. The waste paper was used as raw material for cartons to protect the more than 700,000 war items shipped overseas. Newspapers were used to wrap plants, and magazines were processed and made into cartons for blood plasma. In 1943, Ogden High School won the state contest for collecting 291,000 pounds of waste paper. The citizens of Ogden supplied four boxcars full of paper for the war effort that year.

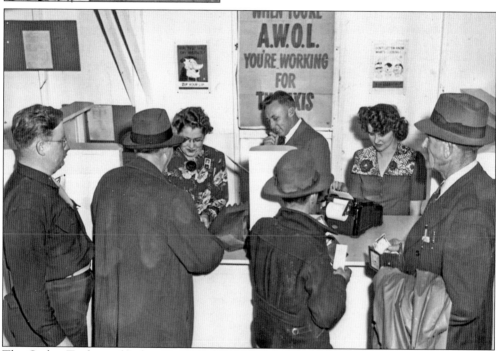

The Ogden Trades and Labor Council was involved in keeping the unions working together to not tie up the war efforts. There was a close working relationship between the unions and military. The Ogden unions were to send men to help build the Quartermaster Depot. The Ogden Ordnance had a priority rating of A1-A, which was the highest given by the Army. Pictured are some working men waiting to get their day's wages. Charles Maccarthy, head of the council, is seen at center behind the counter. (Courtesy of Ogden Union Station.)

In November 1942, about 400 part-time workers came to Ogden from Cache Valley to devote a week in war work at the warehouses and loading platforms. The workers were transported down to Ogden in large school buses and worked at least 10 to 12 hour days. The buses were converted to allow for recreation such as playing cards on the long drive down and back. People came from as far as Preston, Idaho, and the west side of Cache Valley to fill two buses every weekend from September to November to help fill the manpower shortage. (Courtesy of Ogden Union Station.)

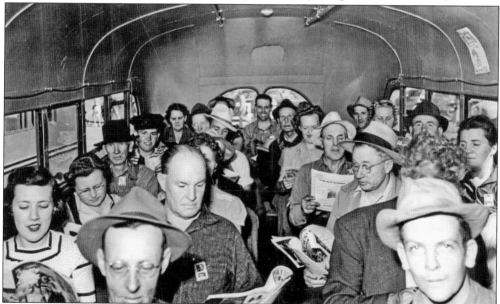

By 1942, there were over 20,000 laborers working at the four depots in and around Ogden. Buses were loaded with hundreds of girls and men responding to the call of duty. The city decided to increase the amount of buses on the road to get people to and from work. Buses became available throughout Ogden for the 8:00 a.m., 4:00 p.m., and midnight shifts. The buses took them south to Hill Field and had transfers up to Huntsville and upper Ogden Valley. (Courtesy of Ogden Union Station.)

In 1944 at Weber College, there were 50 male students enrolled on campus and 450 girls. They tried very hard to carry on many of the traditions. One new tradition was the "Polygamy Prance." The dance allowed a man to take up to seven girls to the dance. According to Dean Hurst, there was even a girl's choice dance so they could dance with someone else. The dances included a conga line and group dances like Virginia reels to get as many girls on the dance floor as possible.

Barratt Chadwick was the voice of northern Utah on the radio station KLO. During the war, he presented his program *On the Home Front*. During the programs, he talked about how Utah was mobilizing for the war. He did in-depth pieces on Tooele Army Depot and the internment camp at Topaz. He worked to provide recreation for soldiers and war workers in the area.

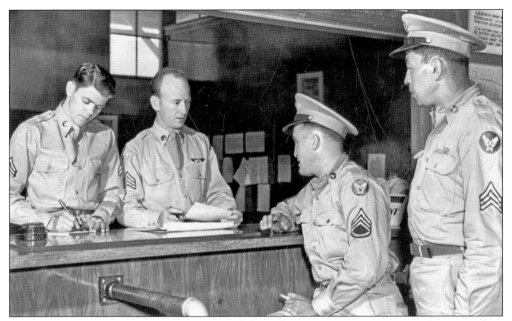

During the war, over a million troops poured through Union Station. Evart Bradley remembers coming through Ogden with a friend on their way to boot camp. While waiting for their train, they decided to find a room on Twenty-Fifth Street. Nothing was available except a shared room without a door, and the two decided to sleep at the train station instead. The soldiers shown here worked at Union Station to help those traveling. (Courtesy of Hill Air Force Base.)

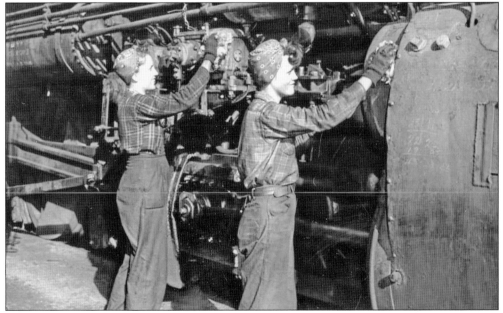

Women performed all kinds of wartime work. The *Salt Lake Tribune* wrote, "it would be difficult to find any masculine field that has not been invaded by the women of today." Most women enjoyed these opportunities, but it was expected that they would only hold them until the men came home. Ruth Olsen (right) and an unidentified woman are pictured here at the Denver & Rio Grande roundhouse in Salt Lake City. (Courtesy of Utah State History.)

The war brought on a shortage of nurses, not only in the military, but also on the home front. To combat this shortage, the federal government established the Cadet Nurse Corps in 1943. Young women were recruited into the program as young as 17 and were offered tuition, a monthly stipend, and special uniforms. Regina Urban Turner joined in January 1944 and trained at the Dee School of Nursing in Ogden.

The Dee School of Nursing was one of more than 1,100 approved schools for the cadet program. In return for their training, the women agreed to remain active in nursing through the duration of the war. Delpha Graves Allen (second from right) is pictured here with her fellow cadets. She joined the corps in June 1945, but the war ended in August. She continued her training though, and worked as a nurse for nearly 40 years.

Cadet nurses received standard and advanced training in first aid from the Red Cross. The Dee School of Nursing graduating class of 1947 completed the training and was able to provide basic care in the event of a mishap. Shown here are, from left to right, Lois Gregory, Lillian DeYoung, and Phyllis Fryer applying a splint to a broken leg.

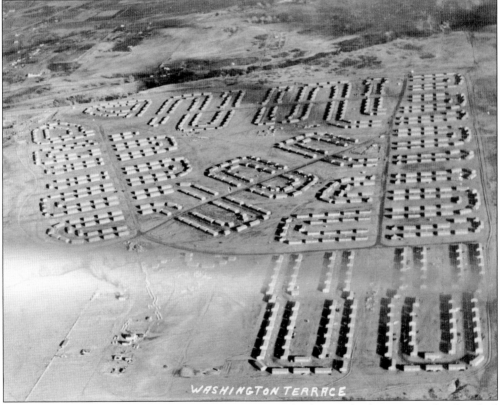

As new military installations were built in northern Utah, thousands of "victory workers" rushed to Ogden and surrounding towns for jobs. Housing was soon in short supply, and Ogden's public housing authority worked with federal agencies to construct several housing projects. One of the largest subdivisions, with 1,400 units, was built on the south end of Ogden. This subdivision, Washington Terrace, was designed with an eight-and-a-half-acre recreation area, where a school was later built.

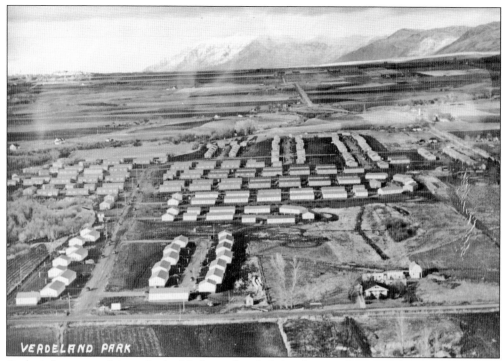

VERDELAND PARK

Ogden's famous architect, Leslie Hodgson, headed the design of most of the victory housing subdivisions, but subcontractors were selected from all over the region. As towns in the area hurried to build houses, citizens were encouraged to help with the housing crisis in any way they could. Many rented rooms to victory workers, and newspapers printed tips to help growing families make do in their current homes by converting attics into living spaces. Two areas were also set aside for commercial ventures. In 1948, Washington Terrace became an independent municipality. Other projects included Bonneville Park in Ogden, Smith Village, Ute Hills in Clearfield, and Verdeland Park, Layton's 400-unit project, shown below.

Nine

VICTORY!
POSTWAR LIFE

As the war drew to a close, there was a collective sigh of relief as the worst of the fighting was over and life could start to return to normal. With the announcement of V-J Day, businesses and federal installations in northern Utah closed for celebrations. There were fireworks and crowds of people gathered to celebrate the end of the war. In Ogden, hundreds of cars circled Municipal Square with horns honking and people shouting. The celebrations went well into the night with food, drink, and dancing at city square.

As the young men began to return home from overseas, they were greeted with open arms and more celebrations. Ogden hosted a welcome home parade in November 1946 and invited all military personnel to march down Washington Boulevard. Veterans saw support from throughout the community with help in housing and job opportunities. Many of the men decided to re-enlist into the military and serve their country even further. Many came home with battle wounds and scars that left an indelible impression on their lives.

Davis County saw its population double over just a few short years. There was an increase in housing, commercial properties, education, and construction opportunities. Weber County changed from an agricultural center to one of industry and commerce with a heavy investment in military installations. Many of the centers saw cutbacks in the workforce until the Korean conflict just a few years later. Women remained in the workforce but in different capacities as returning soldiers went back to work in warehouses and on the farms. The world would never see a war that would have such an impact on the daily lives of everyone from young children to the elderly. World War II was truly everyone's war.

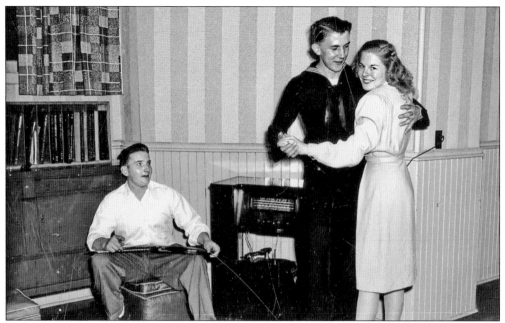

Following the end of the war, groups like the YMCA started programs to help the young veterans readjust to civilian life. In 1946, over 2,000 young Ogden veterans had returned home. The Y provided group programs and leadership to keep them out of trouble. See here are Jeanne Leahy and Joe Allman dancing while C.E. Carlson spins the latest record.

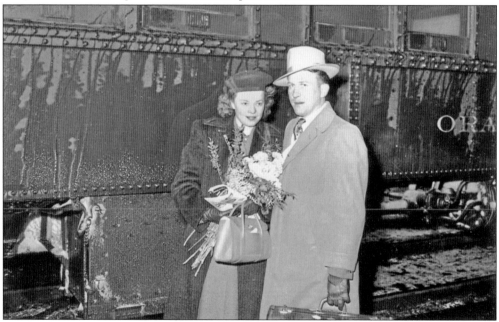

In 1946, Doreen Sessions was one of the 12 British war brides who boarded a train in Chicago to join their husbands in the West. On February 7, 1946, she was greeted by her husband, Royal Sessions, and taken home to Clearfield for a wedding reception and honeymoon. The couple were married in October 1944 and were shocked by all the publicity that surrounded her arrival in Ogden.

In order to help veterans, the Ogden office of the US Employment Service prepared charts on veterans' guidance. The chart shown here with Donna Carey on the left and Venice Carson on the right lists the proper places for veterans to go for information. There were 24 headings that covered all the major subjects of interest to returning veterans and included the names and addresses of the agencies.

On November 11, 1946, the citizens of Ogden held a Victory parade honoring all the World War II veterans. Over 300 veterans from the Army, Navy, and Marines came to attention for a 10-minute ceremony honoring Weber Country's war dead on the corner of Twenty-Fourth Street and Washington Boulevard. The group was led by Medal of Honor recipient George Wahlen and joined by the Ogden High School cadets and World War I veterans.

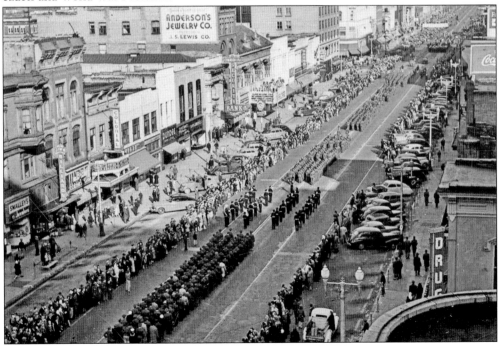

The military housing districts each created their own veteran's club. Shown here are Ernest and Fern Greenwood (left), Mark and Vivienne Birch at the piano, and Robert and Marjorie Goebel of the Washington Terrace Club. The club provided dancing, refreshments, and bingo to all returning veterans, their wives and partners, and widows of veterans. The membership dues were just 50¢ a month.

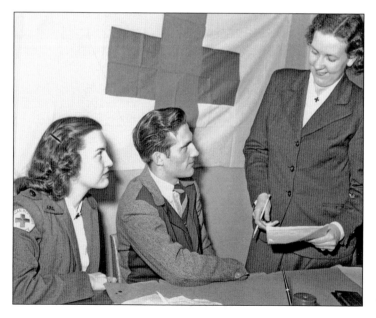

The Red Cross home service unit was created for the benefit of families of service members. They provided communication between service personnel and family members and helped with information about government regulations, pensions, and other benefits, including financial assistance. Pictured here are Melva Campbell (left) and Norma Foulger interviewing a veteran to help him with his problems.

The *Ogden Standard Examiner* was just one of the many local businesses that proudly hired returning veterans. Pictured above are, from left to right, Leon Hedenstrom, who served in the Army Air Corps in Guam; John Aiken, who entered the Army in 1942 and served in the Pacific before returning as co-manager of the engraving department; and T. Boyd Sloan, who served in the Navy in the Pacific. Below is the circulation department, including (from left to right) Mack Whitaker, who served the Army in Europe and joined the paper as a route manager; LeRoy Thorsted, who was in the Army Air Corps and returned to the paper as district circulation manager; and Leon Parsons, who was in the European Theater in the Army before returning as district route manager.

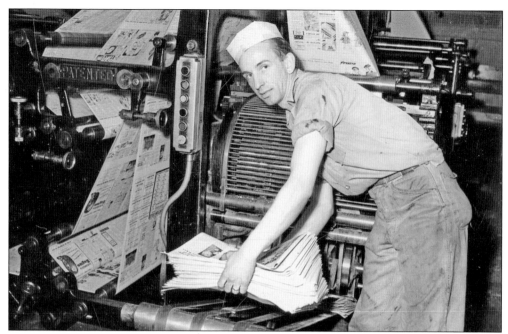

Pictured above is Warren Beus, pressman. He enlisted in the Marine Corps on July 9, 1942, as part of the first Mormon platoon. He served overseas in New Zealand, Tarawa, Saipan, and Tinian. He was released October 12, 1945. Before the war, he worked for the newspaper for one year before he accepted employment at the bomb loading plant at the Ogden Arsenal. In the photograph below are Louis Gladwell (reporter) and Ted Collins (photographer). Gladwell was a specialist in the Navy and saw action in Tokyo Harbor and Okinawa. Collins joined the Navy in October 1940. He was active duty as a photographer's mate and shipped overseas, where he covered fleet activities. He aided with the publicity of the invasion of the Marshall Islands.

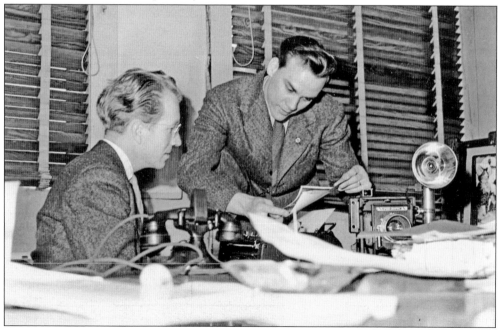

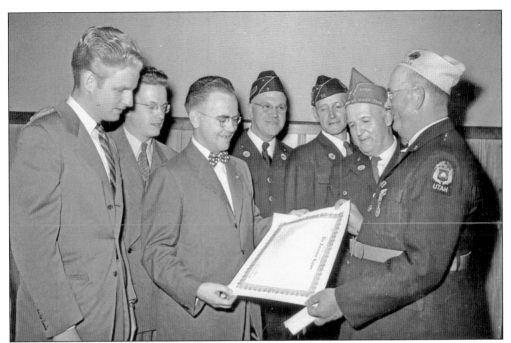

On July 20, 1946, the new American Legion post No. 41 was established in Ogden. The original 27 charter members represented the Army, Navy, Marines, Air Corps, and Coast Guard. The first project was a registration center to help veterans with their housing problems. From left to right are Max Peterson, Max Lamph, Harold Corey, Reid Michelsen, Frank Emmett, Frank Melick, and A.S. Horsley.

Gus and Jeanette Havas lived in Amsterdam with their two children, Bert and Carla, in 1944, when they were arrested by the Gestapo, separated, and sent to concentration camps. Jeanette survived with the children at Ravensbruck, witnessing the horrific experiments performed on other prisoners. They were freed and reunited with Gus in 1945, then immigrated to Ogden in 1955. Gus died in 1968, but Jeanette spent the rest of her life, until 2010, sharing her experiences.

Even as the war was drawing to a close, Ogdenites still heeded Uncle Sam's call and joined the military. Pictured here are Don Edens (left) and Don Hutchinson, 1946 graduates of Ogden High School. They both enlisted and were sent to Fort Knox for tank corps training. After completing training, they were stationed in Japan as part of the tank corps unit.

With the announcement of the surrender of the Japanese, people throughout northern Utah took to the streets to celebrate. It was a much-needed end to a long and drawn out war. Citizens across the country expressed their joy and anxiously awaited the return of their soldiers. Seen here is a large group gathered on Main Street in Salt Lake City on V-J Day.

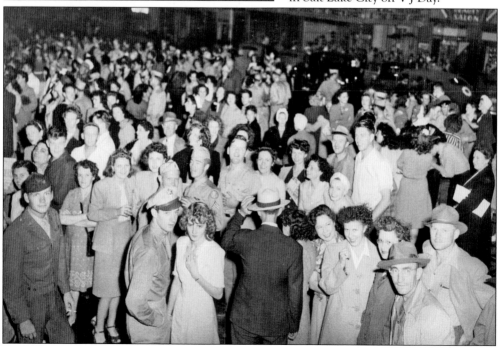

BIBLIOGRAPHY

Air Force Logistics Command. *History of Hill Air Force Base*. Layton, UT: Hill Air Force Base, 1981.

Arrington, Leonard J. and Archer Durham. "Anchors Aweigh in Utah: The U.S. Naval Supply Depot at Clearfield, 1942–1962." *Utah Historical Quarterly* 31.2 (1963): 109–126.

Halverson, W. Dee. *The Life and Times of Thomas D. Dee, II*. Heritage Associates LLC, 2002.

Hill Air Force Base. *From Arms to Aircraft: A Brief History of Hill Air Force Base*. Layton, UT: Hill Air Force Base, 1996.

History Office, Ogden Air Logistics Center. *History of Hill Air Force Base*. Charles G. Hibbard, ed. Layton, UT: Air Force Logistics Command, 1988.

Kalisch, Beatrice J. and Philip Kalisch. "The U.S. Cadet Nurse Corps." *American Journal of Nursing* 76.2 (1976): 240–242.

Noble, Antonette Chambers. "Utah's Rosies: Women in the Utah War Industries during World War II." *Utah Historical Quarterly* 59.2 (1991): 123–145.

Perry, Wilmer. *DDOU: Defense Depot Ogden, Utah History Book*. Ogden, UT: DDOU History Book Committee, 1996.

Petry, Lucile, RN. "The U.S. Cadet Nurse Corps: A Summing Up." *American Journal of Nursing* 45.12 (1945): 1027–1028.

Power for the Pacific Punch: Naval Supply Depot Clearfield. Oakland, CA: Planning Division Naval Supply Depots, 1945.

Rands, Lorrie. "Food, Comfort, and a Bit of Home." *Utah Historical Quarterly* 84.1 (2016): 71–85.

Rice, Helen. *History of Ogden Air Material Area*. Layton, UT: Hill Air Force Base, 1963.

US Army. *Utah General Depot*. Washington, DC: US Army, 1961.

Yellin, Emily. *Our Mothers' War: American Women at Home and at the Front during World War II*. New York, NY: Free Press, 2004.

Discover Thousands of Local History Books Featuring Millions of Vintage Images

Arcadia Publishing, the leading local history publisher in the United States, is committed to making history accessible and meaningful through publishing books that celebrate and preserve the heritage of America's people and places.

Find more books like this at
www.arcadiapublishing.com

Search for your hometown history, your old stomping grounds, and even your favorite sports team.